HAUNTED
HANNIBAL

Lisa Marks
Ken Marks

HAUNTED HANNIBAL

HISTORY AND MYSTERY IN AMERICA'S HOMETOWN

KEN + LISA MARKS

Haunted America

Published by Haunted America
A Division of The History Press
Charleston, SC 29403
www.historypress.net

Front cover: Federal Building, *Lisa Marks*.
Back cover: Mount Olivet Cemetery, *Lisa Marks*; "Indian" Joe Douglass, *Jean and Hal Frazer*;
downtown Hannibal, *courtesy of Steve Chou*.

First published 2010
Second printing 2012
Third printing 2013

Manufactured in the United States

ISBN 978.1.60949.044.7

Library of Congress Cataloging-in-Publication Data

Marks, Ken.
Haunted Hannibal : history and mystery in America's hometown / Ken and Lisa Marks.
p. cm.
Includes bibliographical references (p.).
ISBN 978-1-60949-044-7
1. Haunted places--Missouri--Hannibal. 2. Ghosts--Missouri--Hannibal. I. Marks, Lisa. II.
Title.
BF1472.U6M345 2010
133.109778'353--dc22
2010030762

CONTENTS

CONTENTS

PREFACE

This book was not written for private circulation among friends; it was not written to cheer and instruct a diseased relative of the author's; it was not thrown off during intervals of wearing labor to amuse an idle hour. It was not written for any of these reasons, and therefore it is submitted without the usual apologies.
—*Mark Twain,* The Gilded Age

What makes a place haunted?

Some say hauntings are more often than not the result of untimely death—a sudden, terrible death such as murder or drowning, disease that takes a young life, battles fought in war capturing the souls of young soldiers and, especially in America, the taming of the Wild West and the violence that it produced.

All of these types of events happened in Hannibal, Missouri. But does that automatically mean that Hannibal is haunted?

First of all, "haunted" is a relative term. We can be haunted by memories, haunted by an image we've seen on television or at the movies, haunted by a scary story we were told as a child. A house can be haunted by a former inhabitant. An object may be haunted by a residual trace of energy left behind by the object's previous owner—a doll, for example, that was so beloved by a child that after a hundred years, when another person touches the doll, he or she is overcome by a sense of sweetness, love and joy.

So is Hannibal really haunted, you ask?

When we first moved from our hometown of St. Louis ninety-nine miles north to Hannibal in September 2009, we did not do so to seek out ghosts. Our aim was to try to save Rockcliffe Mansion. Rockcliffe, built in 1900 and open as a museum since 1968, was about to be sold and its museum-quality collection of original contents auctioned away. We moved into Rockcliffe to manage the property and keep the museum intact until arrangements for its long-term ownership and care could be secured.

Although we'd heard rumors, we had no idea that the mansion was really haunted! It only took a few weeks of living at Rockcliffe for us, skeptics though we were, to admit that we were not alone in the mansion. Too many unexplainable things were happening—footsteps up the servants' staircase, doors slamming in the middle of the night, items that were sitting far back on deep shelves mysteriously making their way to the edge and crashing to the floor.

Yes, Virginia, there really are ghosts in Hannibal. At least in our opinion, and in the opinion of many other Hannibalians interviewed for this book.

As many different reasons exist to explain that a place might be haunted as there are stories of hauntings. Each story is unique, although a common theme seems to run throughout—a sense of unfinished business after death. The stories contained in this collection share this theme, although the circumstances of each could not be more different.

We certainly don't profess to be authorities on hauntings. We would not want to attempt to investigate theories on how or why hauntings occur or go into detail about the science of paranormal investigations. We encourage you to seek out books written by professionals in these fields to learn more about the technical side of this topic.

We simply love history; we've become pretty good at storytelling by giving historical and haunted tours; and we are eager to share what we've learned about Hannibal and its colorful past. This book is our attempt to keep the legends and stories alive and share them with both Hannibalians and the guests who visit this wonderful town. We have tried to be as accurate and factual as possible when retelling these tales and ask forgiveness ahead of time for any discrepancies there may be. We are also sensitive to the fact that these stories mostly deal with real persons, both past and present, and we have done our best to be respectful.

We were caretakers of Rockcliffe Mansion until May 2010. We thoroughly enjoyed our time at Rockcliffe and, frankly, grew comfortable

living with the energies with which we shared the mansion. We were so intrigued with Hannibal and its amazing history that we sold our home in St. Louis and purchased a Second Empire Victorian home on Sixth Street (built in 1885 by Joseph Rowe, former mayor of Hannibal), thereby becoming official Hannibalians ourselves. We currently conduct Haunted Hannibal tours daily, taking our guests to the actual sites where hauntings have been reported and exploring the fascinating cemeteries in Hannibal.

We've only been living in our new old home a short while and so far have not experienced any paranormal activity. However, one of the most haunted houses in Hannibal—so haunted that it was featured on the NBC *Today* show as one of the ten best places to "sleep with a ghost"—is directly behind our house.

So, is Hannibal—"America's Hometown," the boyhood home of Samuel Clemens (aka Mark Twain)—really haunted? We will leave it up to you to reach your own conclusions after reading this book, and we encourage you to visit our wonderful hamlet in northeastern Missouri to explore these magical places yourself.

ACKNOWLEDGEMENTS

I t is with great trepidation that we begin this section of the book, with the certainty that we will neglect to thank someone of supreme importance to us. If this means you, please accept our sincere gratitude and forgive our transgression.

First, thank you so much to our parents, Terry and Alice Marks, Dale Crosswhite and Roseann Elmore Crosswhite Hudson; to our amazing children, Jordan Young and Shea Marks; to Gideon and Mary Elmore, whose spirits live on in these pages; and to Uncle Frankie, Frank Elmore. You are the most important people in our lives.

Thank you to Ben Gibson at The History Press for giving us this opportunity.

For all of the people who so graciously gave us their time and their stories, and who are included in this book, thank you all so much.

A shout out to dear friends Robert and Elizabeth Lawrence; John Robinson, who was the one who started us on this adventure; Gloria Austermann and Anna Jefferson, of course; Jackie and Steve Karlock, our mentors; Jim Barone, our champion; Mary McAvoy and Jeane Crowell, for sticking with us; Candace Klemann and Chris Bobek, for showing us the way; Lou and Jenie Barta, who don't seem to think we're insane; Terry Sampson, for your leadership and enthusiasm; Henry Sweets and Cindy Lovell, for keeping Twain alive; Steve and Sandy Terry, for your support and encouragement; Jennifer Johnson and her brood, for making us laugh; Cindy Windland, for giving us a chance and for giving our new

business a home; Brent Engel, Travis Given, Gloria Burns and the staff of the *Hannibal Courier-Post*, for their assistance and support; Ed Trotter, Paul Lewellen, Al and Maudean Sellers, Betty Parsons, C.W. Stewart and the rest of the gang at the Hannibal Trolley Company, for the wheels that keep our haunted tours rolling; Jim and Nancy Talley, O.C. Latta and Christine Carroll, for helping us become true Hannibalians; and J. Hurley and Roberta Hagood, for blazing the trail.

We are grateful to the Friends of Historic Hannibal, the Marion County Historical Society and the staff of the Hannibal Free Public Library for the incredible work they do and the support they've given to us since we first landed in Hannibal.

To Jim and Sheryl Love, who came into our lives when we needed them most and reminded us that there is still kindness and generosity in the world, we thank you so profoundly.

Thank you Steve and Linda Chou, not only for being friends but also for sharing your love of history, particularly Hannibal's history—not just with us, but with anyone who is interested. You remind us all that we do not own anything in this life; we are simply caretakers until it is time for the next one in line to step forward.

And, finally, to Beau Hicks and the entire staff of the Hannibal Convention and Visitors Bureau, we once again say thanks. Beau, from the very first day you have gone out on a limb for us, publicly and without hesitation. (As Twain said, "Why not go *out on a limb?* That's where the fruit is.") You interjected enthusiasm when we needed it most, opened our eyes to new possibilities and literally gave us a shoulder to cry on. Your dreams for Hannibal and your passion for its potential are infectious. You, most of all, made this possible, and for that we are eternally grateful.

HAUNTED HANNIBAL

*After all these years I can picture that old time to myself now, just as it was then:
the white town drowsing in the sunshine of a summer's morning; the streets empty,
or pretty nearly so; one or two clerks sitting in front of the Water Street stores,
with their splintbottomed chairs tilted back against the wall; a sow and litter of
pigs loafing along the sidewalk; the great Mississippi, the majestic, the magnificent
Mississippi, rolling its mile-wide tide along, shining in the sun.*
—*Mark Twain,* Old Times on the Mississippi, *writing about his hometown Hannibal*

On December 16, 1811, a mighty earthquake shook the center of the
United States, one of the most violent quakes ever to be recorded. The
epicenter was found to be in the "bootheel" of Missouri, near a small town
named New Madrid. Its strength caused the Mississippi River to change
course, flowing backward for a short time, and opened a fissure so large
that the Reelfoot Lake in Tennessee was formed, filling with water from the
river's change in course. Residents as far away as Pittsburgh, Pennsylvania,
and Norfolk, Virginia, were awakened by intense shaking; church bells
were reported to ring as far as Boston, Massachusetts; and sidewalks were
reported to have been cracked and broken in Washington, D.C.

The town of New Madrid was destroyed. Residents in the area,
whose land had been rendered useless by the quake, petitioned Congress
for relief. A bill was passed, and the residents were given land grants,
certificates that entitled them to 640 acres anywhere in Missouri that was
still unclaimed and open in the public domain.

Two of these certificates would be used to claim tracts of land in the northeast corner of the state on the banks of the Mississippi River. The new settlement was surveyed in 1819, and Moses D. Bates is credited with the formation of the town, clearing the land and constructing the first buildings to form the new settlement. The settlement's name, Hannibal, was attributed to Don Antonio Soulard, surveyor general for the Spanish government. Before the Louisiana Purchase in 1803, Spain owned the land west of the Mississippi, and after Soulard completed his exploration of the Mississippi River about 1800, the map he later drew of the area bore the name Hannibal.

In 1830, the total population of Hannibal was thirty souls. During Mark Twain's boyhood the town experienced explosive growth, and by 1860 there were more than six thousand Hannibalians.

After Mark Twain left Hannibal to train as a riverboat pilot on the Mississippi in the 1850s, the railroads came to town, and Hannibal grew into a major center of commerce. Lumbermen from around the country heard of the opportunity and set up sawmills along the riverfront; they would purchase logs from forests up north in Wisconsin and Minnesota, tie the logs into rafts, float them down the Mississippi and then mill the lumber in Hannibal. Once milled, the lumber could be sent south by steamboat or west by train. During Reconstruction, when the South needed to be rebuilt and the future western states of Kansas, Oklahoma and Colorado were being tamed by pioneers, all that precious lumber would flow west and south through Hannibal. Lumber barons would become millionaires, and citizens of the town of Hannibal would live the epitome of the Gilded Age through the end of the nineteenth century.

Before the Civil War, the Missouri Compromise allowed Missouri residents the right to own slaves. Many of the families in Hannibal who owned slaves relied on them to assist in household duties and to care for the children. These slaves were very open about discussing their religious beliefs and superstitions, rituals whose roots trace to Africa. These spiritual tools were used by the slaves to cope with their difficult circumstances. The slaves would share these beliefs not only with the children but with other members of the household as well, and their culture would influence the daily lives of all Hannibalians.

It is widely believed that *The Adventures of Tom Sawyer* is actually a thinly veiled autobiography that gives us a firsthand account of life in Hannibal during Mark Twain's boyhood. The novel is filled with incidents of the

children casting spells, discussing ghosts and putting their faith into all sorts of superstition that they had learned to mimic from the adults, both black and white.

In the preface to *Tom Sawyer*, Mark Twain wrote, "The odd superstitions touched upon were all prevalent among children and slaves in the West at the period of this story." Mary Sibley Easton, in the preface to her book *Mary of Mark Twain's Home Town*, concurred: "Everything of which I have written took place in the seventies [1870s]. In those days the superstitions of the colored people and the teachings of the orthodox church entered largely into the home training of young children in Hannibal." Thus, the first seeds of haunted Hannibal were sown during this time, with the townspeople, slaves and children all sharing a fascination of the occult, a fear of the great unknown and a healthy belief in haunts that began early in the 1800s.

The legends and haunted stories of Hannibal have been passed down from generation to generation, with each subsequent generation adding new stories to the old. But what is it about Hannibal that makes it haunted, replete with stories dating back to the time of the town's formation nearly two hundred years ago?

Jamie Grady moved to Hannibal from Pennsylvania in 2003. After witnessing many incidents of paranormal activity, she has developed her own theory as to why Hannibal is so haunted:

It's the limestone and the river, partly. I believe that residual energy is absorbed by porous surfaces like limestone, and brick and wood, and they have energies imprinted on them. Hannibal has a continually shifting electromagnetic field due to our proximity to the New Madrid fault and the continually flowing river. The energy is continually being absorbed, like a record player where things are always played over and over and over; then when the energy shifts, the vibrations can be "played." For a brief moment, the sounds and actions are amplified to the point that living beings are able to sense them. The time/space continuum is much more fluid than people give it credit for.

One resident of Hannibal that we interviewed for this book told us she and her husband like to think that, in the same way the exhibits would come to life in the movie *Night at the Museum*, Hannibal comes to life after dark when no one is looking. Statues around town climb down from their stone pedestals, ghosts of residents past revisit their favorite locales and the town comes to life, unseen by the living. So many Hannibalians over

the town's 190 years have put so much of their hearts and souls here that they simply don't want to leave!

Truly, many of the places in Hannibal that are purported to be haunted seem to be attached to some of the most famous, and infamous, citizens who have lived here. Many of the buildings attributed to Hannibal's lumber barons and wealthy residents (Cruikshank, Pettibone, Garth, Stillwell and others) have haunted stories. These families earned their fortunes in Hannibal and went on to form the infrastructure of the community: churches, parks, hospitals, schools, libraries, even the paving of the roads. Their fingerprints are everywhere. Their devotion to Hannibal is still evident, and the structures and community service projects they spearheaded are enjoyed by today's Hannibalians, as well as by visitors to our town. Is it far-fetched to think that the energy they put forth, and their personal feelings about their homes and businesses, might still be felt in these structures?

Michael Gaines has experienced numerous paranormal events while living in Hannibal. "I have many paintings by a local [Hannibal] artist; her name is Hettie Marie Andrews. After she died, each time I'd pass one of her paintings on the wall, I could feel cold. It's as if she had left traces of her energy on her paintings." He believes that spirits have the ability to linger, and some people are better able to tune into the energies that are left behind. Michael added, "Hettie loved painting. I felt her presence. I could literally 'feel' her in the hallway."

Michael explains his theory:

> We're only using a small portion of our brainpower, our own intuition. Who is to say there's not another whole realm that we don't understand, or that we're simply too scared of to explore? I feel that we'd be underestimating the whole universe if we didn't allow ourselves to think there is the possibility of connecting with those who came before us.

VIOLENT CRIME, DEATH AND GHOSTS DURING SAMUEL CLEMENS'S BOYHOOD

Everything human is pathetic. The secret source of humor itself is not joy but sorrow. There is no humor in heaven.
—*Mark Twain*

He remembered his dead siblings and revisited the guilt of transgressions against them unforgiven. He recalled old sweethearts, often with photographic clarity of the moments of final partings. His manuscript papers reveal, posthumously, that he had carried inside his head a remarkably detailed mythic version of his boyhood Hannibal.
—*Ron Powers,* Dangerous Water

It is well documented, by historians and by the man himself, that Mark Twain was haunted as an adult by things that happened to him during his childhood. Although Twain remembered many joyous moments and retained a fondness for Hannibal all his life, he was also tormented by memories of murder, drowning, accidental death, disease and mischievous pranks gone awry that occurred during his boyhood days on the banks of the Mississippi.

Although he did not come to Hannibal until he was four years old (Sam Clemens was actually born about forty miles from Hannibal, in Florida, Missouri, in 1835), it was Hannibal that Mark Twain thought of as his hometown, Hannibal that he remembered so vividly when he wrote *Tom Sawyer* and *Huckleberry Finn*. It was Hannibal that provided the texture to the tales he would so famously weave in his lifetime. From the

unspeakable tragedies he witnessed and experienced during his boyhood in Hannibal would emerge a comic genius upon which Twain would rely throughout his life. Twain was able to transform the pain of childhood heartbreak that would never leave him into humor and wit that would help him retain his sanity and eventually lead him to fame and fortune.

And tragedy there was. During the years Samuel Clemens was a member of the community, from 1839 to 1853, Hannibal was very much the epitome of a wild western frontier town. Missouri had achieved statehood in 1821, just fourteen years before Sammy's birth, and was then considered the western edge of the nation. (Kansas would not become a state until 1861; Oklahoma, not until 1907.) The mighty Mississippi River that flowed alongside the small town brought to Hannibal's shores rough-languaged roustabouts, riverboat gamblers, land speculators, gold rush forty-niners, traveling minstrel show performers and many other colorful characters; they would form a rowdy, sometimes violent and always entertaining sideshow of humanity.

Young Sammy absorbed everything and seemingly forgot nothing. His curiosity and yearning for adventure were evident at a young age, and the escapades he undertook as a very young boy are inconceivable in today's modern society. But some of these escapades would have consequences—deadly consequences in some instances—and from them Twain would never fully recover.

Take, for instance, young Sammy Clemens witnessing the first premeditated murder in Hannibal's history. On January 22, 1845, when Sammy was just nine years old, a man by the name of Sam Smarr was casually walking down Main Street in front of Grant's Drugstore. His demeanor that day was misleading, however; Sam Smarr was known around town as a notoriously mean drunk. He had a propensity to talk trash when intoxicated, and sometimes in a particularly harsh way.

William P. Owsley owned a mercantile store directly across the street from Grant's Drugstore, just one block from the Clemens residence. Sam Smarr had become obsessed with Owsley, making him a target of his drunken tirades on numerous occasions, saying that Owsley was a "damned son-of-a-bitch" (according to testimonies later taken by Judge John Marshall Clemens). Smarr accused Owsley of swindling

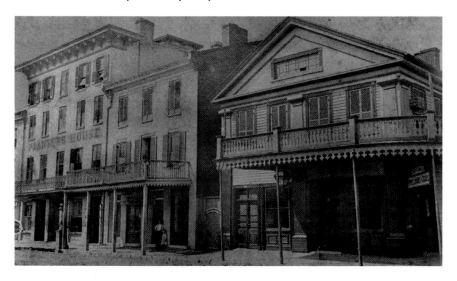

Grant's Drugstore (far right), shown here in the late 1860s, was the site of Sam Smarr's death. *Photo courtesy of Steve Chou.*

a considerable amount of money from the Thompson brothers in Palmyra, Missouri.

Owsley, who did not wish to dignify Smarr's accusations with a response, kept silent. Smarr continued to harass Owsley for several weeks. Apparently, on January 22, Owsley had had enough.

As Sam Smarr walked down the sidewalk in front of Grant's Drugstore, Owsley emerged from his mercantile. He crossed the street, called out, "You! Sam Smarr!" and drew a pistol from his pocket. Smarr turned; some people claimed to have heard him say, "Don't Fire!" Owsley ignored the plea, firing directly into Smarr's chest. He then paused to take aim again and fired a second shot.

Smarr fell but was not yet dead. Grant emerged from his store and, with the aid of several onlookers, carried Smarr into the drugstore and lifted him onto the counter. There, a crowd of curious townsfolk surrounded Sam Smarr, stood by and watched him die. Included in this gathering was young Sammy Clemens.

Owsley was arrested for the murder, tried and acquitted. Maybe the jury thought Smarr had it coming to him. However, after the acquittal, Twain wrote, "there was a cloud upon him—a social chill—and [Owsley] presently moved away."

Another harrowing scrape with death happened to Sammy on one of his many days of skipping school. It was 1843, a day in September, a beautiful month in Missouri. Sammy must have felt it was too much for anyone to ask a young boy to spend a day such as that one at school, and he quietly stole away.

He had lollygagged the day away and, knowing he was in trouble, decided not to go home for dinner. After dark, Sammy was still nervous about going home, so he stayed out most of the evening. By midnight, he had made up his mind that he should accept his inevitable punishment by daylight and chose to sleep in his father's justice of the peace office and return home in time for breakfast.

Sammy climbed carefully in the window of the first floor of his father's office and crawled onto a lounge to go to sleep. Twain recalled many years later, in 1869's *The Innocents Abroad*:

> *As I lay on the lounge and my eyes grew accustomed to the darkness, I fancied I could see a long, dusky, shapeless thing stretched upon the floor. A cold shiver went through me. I turned my face to the wall. That did not answer. I was afraid that that thing would creep over and seize me in the dark. I turned back and stared at it for minutes and minutes—they seemed hours. It appeared to me that the lagging moonlight never, never would get to it. I turned to the wall and counted twenty, to pass the feverish time away. I looked—the pale square was nearer. I turned again and counted fifty—it was almost touching it. With desperate will I turned again and counted one hundred, and faced about, all in a tremble. A white human hand lay in the moonlight! Such an awful sinking at the heart—such a sudden gasp for breath! I felt—I cannot tell what I felt. When I recovered strength enough, I faced the wall again. But no boy could have remained so with that mysterious hand behind him. I counted again and looked—the most of a naked arm was exposed. I put my hands over my eyes and counted till I could stand it no longer, and then—the pallid face of a man was there, with the corners of the mouth drawn down, and the eyes fixed and glassy in death!*

The victim was James McFarlane, a man who had been stabbed earlier in the day by the blade of an eight-inch knife. The accused was Vincent Hudson. The two had been drinking and had quarreled over the ownership of a plow. Judge Clemens had planned to do his investigation and then to have McFarlane embalmed the next morning, so the body

had been left in his office overnight. Sammy had never made it home to hear that a murder had taken place in Hannibal that day.

Twain comically described his exit from his father's office that night:

> *I went away from there. I do not say that I went away in any sort of a hurry, but I simply went—that is sufficient. I went out at the window, and I carried the sash along with me. I did not need the sash, but it was handier to take it than it was to leave it, and so I took it. I was not scared, but I was considerably agitated.*

Not all of the situations young Sammy found himself in ended so comically. On a hot August day in 1847, Sammy and his "gang," which included John Briggs and Will Bowen, had made their way halfway across the Mississippi to fish and swim on Sny Island, a small patch of land and trees in the middle of the river.

Just a few weeks earlier, Neriam Todd, a young slave from Monroe County, Missouri, had run away and made it over to Sny Island on his way across the river to the free state of Illinois. He was discovered by Bence (also called Ben) Blankenship, the older brother of Tom Blankenship (Tom was Twain's inspiration for the character of Huckleberry Finn). At this time, anyone finding a runaway slave was considered heroic if they returned the slave to his/her owner; as a matter of fact, it was a crime not to do so. In addition, the Blankenship family was one of the poorest in the community, and along with the accolades Bence might receive, returning the slave would also fetch Bence a hefty reward.

Twain would recall Bence Blankenship's moral dilemma decades later as he began to work on *The Adventures of Huckleberry Finn*. Just as did the fictional character of Huck, Bence Blankenship chose to help the runaway slave rather than to selfishly turn him in for the reward. Bence began to make the dangerous journey across the river to Sny Island daily on his raft to bring food and supplies to Neriam, and he would continue to do so for several weeks.

Eventually, however, word circulated that the runaway slave might be hiding on the island. A group of woodchoppers went across the river and over to Sny Island with the intent to capture Neriam and return him for the reward. The group soon discovered the runaway, and while he was being chased toward an area of the island called Bird Slough, Neriam Todd was killed.

Sammy and his friends had no thoughts of Neriam Todd on the hot day in August as they splashed and played at the water's edge on Sny

Island. Soon, however, the boys' fun turned to sheer horror when, slowly rising from underneath the surface of the murky brown water, a face appeared. Neriam Todd's mutilated body had been trapped by mud and debris in the river, and the boys' swimming had dislodged the corpse. As the boys swam away in terror, their churning of the river water actually caused the runaway's body to float along with them, and the boys all believed that the corpse was chasing them as they tried to make their escape back across the Mississippi to Hannibal.

Yet another incident occurred while young Sammy and his friends were swimming. This time, the boys were not on the Mississippi; they were bathing at their favorite swimming hole in Bear Creek, a small tributary on the south side of Hannibal that wound its way away from the river.

Village coopers, who constructed items such as burial caskets and wooden barrels, would submerge hickory branches in Bear Creek to soak them and make them pliable. The boys had created a game with the hickory branches whereby they were to dive underwater, hold on to the poles and see who could stay under the longest.

One of the boys—Dutchy, a German immigrant's son who was widely known for having recited three thousand verses of Scripture one Sunday school morning without missing a word—was having trouble staying under water very long. The other boys began to taunt him and would intentionally miscount how many seconds Dutchy was able to stay under water. Dutchy pleaded with the boys to give him an honest count, and when they agreed to do so, he dove under water to give it his best effort.

The other boys quickly hid behind a patch of blackberry bushes so that when Dutchy arose from the water triumphant, no one would be there to congratulate him. They waited, but Dutchy never emerged from under water. Sensing trouble, the boys drew straws to see who would go in after Dutchy. Sammy, naturally, drew the short straw.

As Twain later explained, "The lot fell to me and I went down." He went under and found that Dutchy had become trapped among the hickory poles and had drowned.

I fled to the surface and told the awful news…Some of us knew that if the boy were dragged out at once he might possibly be resuscitated but we

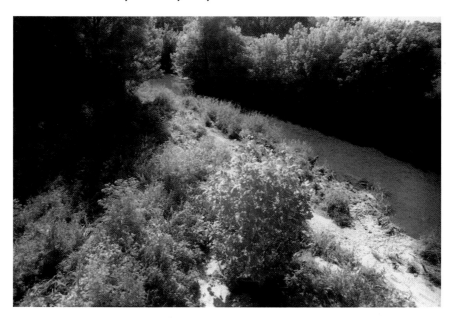

Bear Creek winds its way from South Main Street throughout Hannibal alongside the railroad tracks. *Photo by Ken Marks.*

never thought of that. We did not think of anything; we did not know what to do, so we did nothing.

Eventually, the boys ran into town for help, and Dutchy's body was pulled from the creek.

This was yet another tragedy that Twain added to his growing list of unforgivable incidents for which he felt personally responsible. "All heart and hope went out of me," Twain would lament in his recollection of the incident in *Life on the Mississippi,* "and the dismal thought kept floating through my brain, 'If a boy who knows three thousand verses by heart is not satisfactory, what chance is there for anybody else?'"

Then there was the heartbreaking outcome of another of Twain's boyhood escapades during the winter of 1849. Sammy and his friend Tom Nash, the son of the town's postmaster and part of Sammy's gang, decided to sneak away from home late one night and go ice-skating on the Mississippi. Twain would make light of the boys' caper in his ghostwritten autobiography,

saying, "I cannot see why we should go skating in the night unless without permission, for there could be no considerable amusement to be gotten out of skating at midnight if nobody was going to object to it."

Sammy and Tom skated about by moonlight, eventually reaching as far out as half a mile on the frozen river. Suddenly, they began to hear pops and cracks and realized that the ice was beginning to break up. The two boys, now seriously afraid of the mighty Mississippi, carefully began to make their way back to shore:

> We started for home, pretty badly scared. We flew along at full speed whenever the moonlight sifting down between the clouds enabled us to tell which was ice and which was water. In the pauses we waited, started again whenever there was a good bridge of ice, paused again when we came to naked water, and waited in distress until a floating vast cake should bridge that place. It took us an hour to make the trip—a trip which we made in misery of apprehension all the time. But at last we arrived within a very brief difference of the shore.

Now near the banks of the river, the boys leapt toward the Missouri shore. Sammy made it; Tom did not. "He got a bitter bath," Twain wrote,

> but he was so close to shore that he only had to swim a stroke or two—then his feet struck hard bottom and he crawled out...He [Tom] took to his bed, sick, and had a procession of diseases. The closing one was scarlet fever and he came out of it stone deaf.

Twain could never forgive himself, believing all his life that he was responsible for Tom's disability.

———

But the tragedy that was the hardest for Mark Twain to overcome happened during his grand adventure to become a riverboat pilot in the summer of 1858.

Sammy Clemens had a younger brother named Henry, two years his junior and the youngest of John Marshall and Jane's children. Although Sammy loved Henry, he must have also slightly resented the attention Henry inevitably received as the baby of the family, particularly from their

mother, Jane. In addition, Henry was notoriously good, exemplifying the very antithesis of Sammy's daily mischief.

"My mother had a good deal of trouble with me but I think she enjoyed it," Twain explained in his autobiography.

> She had none at all with my brother Henry…and I think that unbroken monotony of his goodness and truthfulness and obedience would have been a burden to her but for the relief and variety which I furnished in the other direction.
>
> I never knew Henry to do a vicious thing toward me or toward anyone else—but he frequently did righteous ones that cost me as heavily.

Some people asked Twain if his brother Henry was the model for Tom Sawyer's half brother Sid. Twain's response was that "Henry was a very much finer and better boy than Sid ever was."

In the spring of 1858, Sam Clemens was training as a riverboat pilot aboard the steamboat *Pennsylvania*, being mentored by a man named William Brown. Meanwhile, Henry was nineteen years old, living in a boardinghouse in St. Louis and working odd jobs. During his free hours, Henry was content to haunt the local library.

Sam somehow convinced Henry to abandon his simple pursuits and set out on the river on a new adventure. Henry agreed to join his elder brother, and as Sam continued his training under Brown, Henry worked unpaid as a mud clerk (assigned to disembark when the boat would dock to load freight). Working in this fashion, it was possible that Henry would be able to earn the respect of the captain and therefore be considered for a paid position, working his way up to chief clerk or some other high-ranking office.

Sam and Henry would make six trips together aboard the *Pennsylvania*. Sometime near the first of June, the two brothers were in St. Louis for a three-day layover. While in St. Louis, Sam was staying in the home of his sister Pamela; Henry was bunking onboard the *Pennsylvania* so as to be available for his early morning duties.

One morning at breakfast, Sam told his niece Annie of a nightmare he'd had the night before:

> I had seen Henry a corpse. He lay in a metallic burial case. He was dressed in a suit of my clothing and on his breast lay a great bouquet of flowers, mainly white roses, with a red rose in the center. The casket stood upon a couple of chairs.

Sam felt the dream was so real that he paused before entering the sitting room in Pamela's house that he'd seen in the dream, afraid he'd open the door to find a coffin. Later that morning, as he left the house, he reminded himself that it was only a dream and felt a "grateful upheaval of joy of that moment." Still, only a few steps later, Sam felt compelled to turn back and return to the house to again confirm that there was no coffin in the parlor; he "was made glad again, for there was no casket there."

Later that day, the *Pennsylvania* left St. Louis and headed downstream toward New Orleans. During the voyage, the Clemens boys had a run-in with William Brown, the pilot mentoring Sam. It seems that the ship's captain, John S. Klinefelter, had asked Henry to relay a message to Brown to stop at a plantation that was a short way down the river. Brown, who was a bit hard of hearing but didn't like to admit it, must not have heard Henry when he relayed the message, but Sam witnessed the scene and knew Henry had tried to get the information to Brown. Later, when Brown passed the plantation without stopping, which infuriated the captain, Brown said Henry had appeared to him earlier but had never said anything about the captain's message. Sam, however, knew differently and told the captain so.

In response to Sam's betrayal, William Brown ordered Henry out of the pilothouse, and as Henry made his exit, Brown attempted to hit Henry in the back of the head with a lump of coal. "But I was between with a heavy stool," Twain would recall, "and I hit Brown a good honest blow which stretched him out." Sam then proceeded to pummel Brown with his fists, the only outburst of violence Sam Clemens was to ever demonstrate in his entire life.

Captain Klinefelter eventually sided with the Clemens boys, but he needed a pilot to complete the journey to New Orleans, so Brown stayed aboard. Once in New Orleans, a pilot could not be found to replace Brown, so Captain Klinefelter had no choice but to keep Brown aboard the *Pennsylvania*. The captain arranged for Sam to board another boat, the *A. T. Lacey*. Henry would remain part of the crew of the *Pennsylvania*.

Henry left New Orleans aboard the *Pennsylvania* on June 9, 1858, and the *A. T. Lacey* pulled away two days later with Sam as its steersman. On Henry's twentieth birthday, June 13, Sam's steamboat reached Greenville, Mississippi. A man on the levee appeared, and Sam heard him shout, "The *Pennsylvania* is blow up at Ship Island, and a hundred fifty lives lost!"

The *A. T. Lacey* steamed toward the disaster. One newspaper from Memphis had a report of those aboard the *Pennsylvania* and their fate;

Henry was listed as unhurt. Farther upstream, when the crew of the *Lacey* received an updated report from Memphis, Henry was described as "hurt beyond help."

As Sam's ship approached the site of the explosion, chunks from the *Pennsylvania* were floating downstream, and among the debris human corpses could be seen. Sam learned that survivors from the *Pennsylvania* had been taken north to Memphis. He arrived there on Tuesday, June 16, and after finding his brother in a temporary hospital inside the Memphis Exchange, Sam telegraphed his sister Pamela in St. Louis: "Henry's recovery is very doubtful."

When the *Pennsylvania* exploded, Henry had been sleeping in a stateroom directly above the boilers. The blast threw Henry straight up into the air, and he landed in the river. A similar fate had befallen William Brown. Brown died clinging to a piece of the *Pennsylvania* that was floating in the river. Henry, although terribly scalded by the hot steam produced from the ship's boilers, was able to swim to shore.

Remarkably, a reporter for the *Memphis Morning Bulletin* witnessed the moment that Sam Clemens found his brother Henry at the makeshift hospital and reported the incident in a story entitled "The Disaster to the Steamer Pennsylvania: Statement of an Eyewitness" on June 22, 1858:

> *We witnessed one of the most affecting scenes at the Exchange yesterday that has ever been seen. The brother of Mr. Henry Clemens, second clerk of the* Pennsylvania, *who now lies dangerously ill from the injuries received by the explosion of that boat, arrived in the city yesterday afternoon, on the steamer* A.T. Lacy [sic]. *He hurried to the Exchange to see his brother, and on approaching the bedside of the wounded man, his feelings so much overcame him, at the scalded and emaciated form before him, that he sunk to the floor overpowered. There was scarcely a dry eye in the house; the poor sufferers shed tears at the sight. This brother had been pilot on the* Pennsylvania, *but fortunately for him, had remained in New Orleans when the boat started up.*

Awash in self-recrimination, Sam wrote a letter to his sister on Friday, June 18, alongside his critically ill brother.

> *Long before this reaches you, my poor Henry—my darling, my pride, my glory, my all, will have finished his blameless career, and the light of my life will have gone out in utter darkness…Men take me by the hand and*

call me "lucky" because I was not on the Pennsylvania *when she blew up! May God forgive them, for they know not what they say!*

Henry slipped away early on the morning of June 21. Most of the victims who died were placed in white pine coffins, but being a favorite of the hospital's volunteers, Henry had been placed in a metallic case purchased with donations from the volunteers. When Sam returned to the Exchange, Henry was inside the coffin, dressed in one of his older brother's suits. It was Sam's dream realized. Mark Twain would later write:

And I think I missed one detail; but that one was immediately supplied, for just then an elderly lady entered the place with a large bouquet consisting mainly of white roses, and in the centre of it was a red rose, and she laid it on his breast.

Sam accompanied his brother's body to St. Louis via steamer and then up another one hundred miles north to Hannibal. There, with his mother, Jane, and other siblings gathered together, Henry was buried on June 25 in Old Baptist Cemetery, next to his father.

———✦———

And so, all his life, Twain would bear the scars of these tragedies. They would haunt him in his dreams just as they tormented him in waking hours. Tragedy did not escape him once he was removed from Hannibal; Twain would outlive his wife and three of his four children. He would make a fortune, then lose a fortune and then make a fortune again. His personal life would pay the price for his literary success.

Twain himself believed in the paranormal. This belief certainly started in his childhood. It is possible that the story of Tom Sawyer and Huck Finn taking a dead cat to a cemetery and chanting an incantation to relieve warts was based on some real-life childhood experience of young Sammy Clemens in Hannibal.

As an adult, Twain was known to be an early member of the Society for Psychical Research, a group formed in 1882 at Trinity College, located in Cambridge, United Kingdom, "to understand events and abilities commonly described as psychic or paranormal by promoting and supporting important research in this area" and to "examine

allegedly paranormal phenomena in a scientific and unbiased way." Twain would attend séances, particularly after losing a loved one, and was always curious about the ability to communicate with those who had "passed over." Twain was certain that his dream of Henry's death was a premonition; it is possible that other such instances occurred throughout Twain's life and were hinted at in some of his later writings.

Both Mark Twain's fictional and nonfictional works were a constant rehashing of his personal experiences, and where he was most celebrated during his lifetime, on the lecture circuit, he would recall again and again things that happened to him as a boy in Hannibal, Missouri. Twain could never stop the voices in his head, but by vetting them at such lectures he could achieve a temporary sanity, turning his anguish into artfully told stories that would mask the underlying sadness and pain.

The American classic *The Adventures of Tom Sawyer* has never been out of print since its first edition was released in 1876. To the present day, people the world over still delight in Sam Clemens's boyhood capers and, through them, relive the life of Hannibalians in the middle of the nineteenth century. The stories of Mark Twain and his beloved, sometimes tragic, Hannibal will live on forever.

MARY OF MARK TWAIN'S HOME TOWN

As my name is Mary and this, my autobiography, is written of my child life in Hannibal, it would be safer to entitle this little book, "Mary of Mark Twain's Home Town," than just, "Mary of Hannibal." There might be a misprint in the latter and it might meet the fate of the unfortunate poem dedicated years ago to "Mary in H…L"… Sam Clemens…saw the love poem to Mary in H…L, he published it, but put in brackets under the poem "Will let this thing go this time, but the next time Mr.--- wishes to communicate with his friends in H…L he'll have to select some other medium than this paper."
—Mary Sibley Easton, Mary of Mark Twain's Home Town

We are proud to call Steve Chou our good friend. Steve is known around Hannibal for his amazing collection of photographs, ephemera and historical items related to Hannibal. He has published several books on Hannibal's history and continues to donate, with no compensation, antique photographs from his collection to be published and placed online by the *Hannibal Courier-Post* so that others might enjoy them and, hopefully, to spark interest in Hannibal's rich history. He is currently trying to digitize his more than eleven thousand items so that they can be more easily shared with others. He has most generously offered for our use some of the photographs you'll see in this publication.

Recently, Steve shared with us a small book he has in his collection called *Mary of Mark Twain's Home Town*, written by Mary Sibley Easton. It is a remarkable book, only seventy-eight pages long. It is her personal

account of growing up in Hannibal during the 1870s. With Steve's permission, we would like to share excerpts from the book, some of which illustrate the influence that the African American servants had on the children of Hannibal and startling paranormal experiences that suggest Hannibal has been haunted for a very long time.

Mary's grandfather was Rufus Easton, private secretary to Thomas Jefferson. Her father, Joseph Easton, was born in St. Louis in March 1812 after Rufus Easton had been sent to Missouri by Jefferson to "investigate the activities of Aaron Burr during the time of his trial." Joseph Easton would graduate from Yale University and, in 1839, while in New Haven, Connecticut, met and married Jane Smith, the daughter of the honorable Nathan Smith, U.S. senator from Connecticut. Mary's aunt, Mary Easton Sibley, for whom she was named, was the founder of Lindenwood College in St. Charles, Missouri, and is considered a pioneer and champion of the education of women.

Mary was born on September 1, 1863, in Palmyra and moved to Hannibal when she was two years old. She was raised by an African American named Dilsie; one chapter of Mary's book is entitled, "Anecdotes about Mary's Colored Mammy Dilsie." Two other black servants were involved in the Easton household, as well: Aunt Kitty, the cook, and Henry Clay, the house servant. Dilsie and the other household servants were influential in Mary's life, and Mary recalled their interactions in her autobiography.

One tale illustrates the effect religion had on the black community in Hannibal and the curiosity it aroused in the white, mostly Protestant children:

That night, after she gave me a bath [Dilsie] *sang me to sleep with her favorite song about "In some lonesome graveyard, Oh! Lord how long." She went the same evening to a colored Baptist revival on Center street, got religion, fell in a trance the next morning in the kitchen pantry under the back stairs in our home on Fifth Street and Brother Dove, the colored preacher, had to come and pray her out of the pantry. The preacher asked Aunt Kitty, the cook, to "jine" him in singing to her, "Go down Moses, way down in Egypt Land, tell old Phario [sic] to let my people go"; and he said, "Dilsie is clean up on her feet and was right smart perter than she had been since she was a young girl."*

This miracle was told the next Sunday by Brother Dove at evening service in the old church on Center Street, the congregation singing again the strange hymn interspersed with shouting and moans from the large audience.

It is interesting to note that Mary was taken to African American church services, certainly with permission from her parents. This would have allowed the child to form a bond with her mammy and understand the servants on a deeper level; perhaps this is why so many servants were considered part of the family.

Another excerpt from Mary's book tells a chilling tale of the dangers of medicine in the nineteenth century and of a paranormal experience that Mary recalled some sixty years after its occurrence:

> *Dilsie's curiosity got the better of her usual care of me when in about a week a beautiful young lady died very suddenly. I heard the colored nurses in the park talking about the beautiful Miss B.B. Her mother was a widow and had a large business of her own in Hannibal. Miss B.B. was very lovely and her mother bought fashionable clothes for her in St. Louis. Dilsie said she had heard she was an arsenic eater and that was the reason she was so white, and had such an exquisite complexion. Dilsie heard that while Miss B.B. was dressing for a ball she took an over-dose of arsenic to make herself radiant for the evening and she dropped dead.*
>
> *This was too much excitement for Dilsie. There was a large church funeral and Dilsie took me with her. When the service was over, the minister told the congregation that they might take the opportunity to march up to the altar to take a last look at Miss B.B. Dilsie took me by the hand and we marched up to the altar. As we approached the casket Dilsie took me under each arm and held me up over the beautiful dead face. Miss B.B. looked like a lovely cameo. She had very regular features. Her dark brown hair was parted in the center and falling in soft waves about her forehead and was drawn back smoothly over her ears. She wore a heavenly blue silk dress and there were tuberoses on her breast.*
>
> *At the time I was not so much frightened by my first vision of the dead for I told Dilsie she was so perfect she looked like the sleeping beauty in my fairy book. Before tea that evening I told my mother I had seen Miss B.B. in her coffin asleep, and my mother called Dilsie and told her she must not take me to any more funerals.*
>
> *I happened to leave the table alone and walked into the library, and sitting in a large chair facing the fire-place I saw Miss B.B. there in her heavenly blue silk dress with the tuberoses on her breast. I did not move and when the family came into the room they found that I had fainted and had fallen to the floor.*

Next, Mary offered a small anecdote that outlines a superstitious belief held by Dilsie:

One morning Dilsie came to my room to make a fire in the heating stove. Dilsie said that if she made a poor fire that it was a sure sign she would marry some no account nigger so she sure was gwine to make a good one and she did.

Another haunting experience happened at the Easton household and was reported in Mary's autobiography:

Aunt Jane, an old colored woman over seventy, was accustomed to carry the laundry basket on her head from West Center Street up to our house on North Fifth Street. One day as she was bringing it around the corner of the house I heard her scream and went outside and found her on the ground picking up the contents of the large basket. The lovely things as white as snow and so beautifully ironed were lying in the mud. As I helped her she said,

"Oh, Miss Mary, chile, as I was passing that basement window something white was waving with long white arms to me and I fell prosperous on the ground. Oh Miss Mary, I think it was the skelikin [sic] of a poor old white union man who was hung with a clothes line in the back yard of this heah house during the war."

And another:

Dilsie and Henry Clay were told to clean out and whitewash the closet under the stairs. There was an old banjo clock, a set of andirons, a bellows and some other things that my mother said they could have… Henry Clay said, "Hold on there, Dilsie, somf'in else obar dar in dat dar corner"—and he pulled out two skeleton feet. He just hollered and ran into the hall and out into the yard and rolled over on the grass praying to himself all the time.

Dilsie and I went out to look at him and Dilsie said, "Dem must hab been de feet of some poor white trash that de doctor got from de pest house on Holiday's [Cardiff] Hill."

To this day when I am not well I dream of those feet and the dark closet, and I never would go down into the basement for apples, nuts, or persimmons.

One of the most vivid memories Mary recalls in her autobiography is a tragedy that also haunted Mark Twain, yet another in a series of traumatic incidents that occurred during his childhood. When just a boy in Hannibal in the 1840s, young Sammy Clemens had helped a man stumbling down Main Street, drunk, who was looking for a match to light his pipe. Sammy gave him several matches that he happened to have in his pocket. What happened to the drunken man later that day would horrify young Sam Clemens, as he would take responsibility for the man's demise and be haunted by the memory for the rest of his life.

Mary wrote:

> One of the favorite routes for picnics was along the shore of the Mississippi River beneath the hills where ferns and wild flowers grew… In going on any of these delightful excursions we were obliged to pass an old rock calaboose [jail building]. This was built of heavy rough rock and was only one story high. It had two small windows with heavy iron bars. The door filled me with awe. It was heavy, dark, and greasy looking, and had large iron bands across the wood. The lock on the outside of the door was made of iron and was as large as our family dictionary. Once in a while I saw the keeper unlock the door with a key that was the size of our iron beef steak pounder. The windows in the calaboose were high and just under the low roof.
>
> …I had heard from Dilsie that many, many years before I was born a good for nothing white man who had been put in there dead drunk and was there alone that night trying to smoke a pipe, had set his cot of straw on fire and was burned to death before the keeper could be found who had the key to unlock the one big door. No matter how happy and full of enjoyable expectations I was on my way to the fish fries or picnics, whenever I came near the Calaboose, I smelled fire and brimstone.

Mark Twain would remember the old calaboose and write it into his story *The Adventures of Tom Sawyer* as the jail that held Muff Potter as he awaited his trial, framed by Injun Joe for the murder of Doc Robinson at the old cemetery.

Mary, in her book, expressed a fascination with the religious practices of the black Baptists in Hannibal and told of another church service she was allowed to attend:

One Sunday afternoon Dilsie asked my mother if she could take Miss Mary down to the river to see a colored baptizing…An…equipage that had reached the water edge was an old wagon with barrel hoops tacked on to form arches and canvas stretched over the hoops like an old fashioned mover's wagon. I asked Dilsie what that funny wagon was for. She said, "Dat is to toe de brother and sister in after Brother Dove has washed their sins away in de ribber and has made dem as white as a white dove of peace with an olive branch in its mouf." The beautiful singing began, with twists and turns of tone in beautiful minor keys… Then Brother Dove prayed—the congregation interrupting with moans and groans.

…There are tears in the eye of "Mary of Mark Twain's Home Town." I can hear, as I write, the heavenly harmony of that music floating over the silvery waters of the old river. It sinks into my consciousness, bringing with it the hope that such harmony may come to be when I have crossed the bar.

Among the others who went with Brother Dove down into the water to be baptized was a tall, thin, colored woman. Brother Dove became full of the power and sang a kind of revival chant such as he had often used at protracted meetings and at basket picnics. The tall woman began to shout as the congregation sang, "Been down to the water to be baptized; there is glory in my soul." The woman's shouts grew louder and louder and Brother Dove had to put her under the water several times before she stopped jumping up and down; and at last they carried her in her soaking white clothes to the mover's wagon covered with canvas while the chorus at the river's edge sang, "Swing low sweet chariot, looking for to carry me home."

Mary added to her text, "It may seem strange to the reader that no matter how gruesome or how horrible the stories told by the colored people to me at the time were I never feared, but loved the people who told them." This is yet another indication of how influential the household servants were in Mary's upbringing and how they were truly cherished, loved in the way one would love his closest blood relative.

Mary returned to Hannibal just prior to the publication of her autobiography. There is no date of publication located anywhere in the book, just the name of the publishing firm. Clues lead us to believe that the book must have been published sometime after 1930, sixty years after most of the incidents relayed in the book had occurred.

Her closing chapter shows the melancholy she felt upon her return to her childhood home and lends evidence to the theory that some spirits may haunt Hannibal simply because they cannot bear to leave their beloved community:

Three years ago I returned there [to Hannibal] *at nightfall and spent the night in the Mark Twain Hotel. My room had a south window and when I arose the next morning I look out upon dear old Lover's Leap. After breakfast I went out to inquire about the driver who was to take me up to Riverside Cemetery situated on the high chain of hills joining Lover's Leap. "Injun Joe" and many old drivers I once knew had died, but I happened to find that the man who drove me up to Riverside was one who had known me when a child. It was a Sunday morning in May and it was Mother's Day. As I knelt at my parents' graves to place some wreaths of flowers, I asked only to be alone. The river was sweeping by in all its full majesty, the light waves making a low swishing sound as they struck the shore under the hill. I sat there in the sublime stillness looking at the number of little islands in the river and from there across the river to the green lowlands of Illinois. I longed to remain on and on in the wonderful silence.*

…We left Hannibal over a railroad which crossed the river to the Illinois side. As we reached the center of the bridge I stood on the platform of the observation car just at sunset and saw the after glow spreading upon the hill where the statue of Mark Twain, facing the river, stood out alone against the sky…I threw a long, lingering, wavering kiss to "my little home town between the hills"; and looking again at the statue on the top of the hill in the gathering darkness, I said aloud, "I will come again."

THE ENCHANTMENT OF ROCKCLIFFE MANSION

Prosperity is the best protector of principle.
—*Mark Twain,* Following the Equator

Eight blocks west of Mark Twain's childhood home on Hill Street lies the largest mansion in Hannibal—the trick for visitors is in finding it. Rockcliffe Mansion hides behind a thicket of loping locust trees on three sides at one of the higher points of the historic district yet offers from its cupola a panoramic view of the downtown area. The trees add mystique and a sense of isolation to an estate that has been considered the "Haunted House on the Hill" for over four decades.

The 13,500-square-foot, thirty-room mansion was built as a dream home for J.J. Cruikshank Jr., one of the most successful lumber barons in Hannibal when the town was the fourth-biggest manufacturer of finished lumber in the country. Cruikshank Jr. had taken the reins of the business from his father, John J. Cruikshank Sr., who in 1856 had seen (like other ambitious lumbermen) the potential of Hannibal as a major hub for transporting raw materials to the west and had moved his family and business there from Alton, Illinois. After the Hannibal–St. Joseph Railroad line was completed in 1859, up to a dozen milling companies dotted the riverfront landscape; by the late 1870s and early 1880s, the town had become quite affluent for its size of about eleven thousand residents. A "Millionaire's Row" of houses spread the length of Fifth Street, funded through the success of the lumber and railroad industries.

As Fifth Street housed the biggest of the lumber barons of the era, much of the affluence can still be seen in surviving homes across the downtown area, since many residents had bought railroad and/or sawmill shares as a way of securing their futures.

In this competitive environment, J.J. Cruikshank Jr. proved to be a highly motivated and shrewd businessman. He had taken his father's respectable output of ten million linear feet of lumber production per year and quadrupled it. By the 1880s, in addition to the original lumber mill and yard located between Hill and North Streets near Main (next to Mark Twain's boyhood home, separated by a firewall that stands today), the Cruikshank Lumber Company maintained a second yard that spanned three square blocks along Collier Street (now part of Warren Barrett Drive) west of Main, along the railroad line and within walking distance from the original Cruikshank Jr. mansion at the southern tip of Fifth Street (now the O'Donnell Funeral Home). Fueled—so to speak—by his success, he had also spearheaded his own coal company and later opened a door and sash company. In short, he had anticipated the needs of those either settling the Wild West or reconstructing the Old South and invested heavily in the raw materials crucial to both movements.

Although Cruikshank Jr.'s business life had appeared to be well controlled, his personal life leading up to his retirement and involvement with Rockcliffe had experienced a series of highs and lows. In 1859, he married Mary Bacon, daughter of another prominent family who lived in Hannibal along Millionaire's Row, and they raised four children together over the next twenty-five years. Their marriage ended in divorce in 1884 over cross-allegations of adultery that caused a split and eventual dissolution of the First Congregational Church; the divorce case and settlement were sizable enough to warrant coverage in the *New York Times*, which reported that Mary Bacon Cruikshank received $80,000 in alimony and was also awarded a house (although not the home on Fifth Street mentioned earlier). Two years later, J.J., as he is often called today, married again, this time to Anna Louise Hart, a twenty-two-year old who happened to be roughly twenty-six years his junior. Between 1887 and 1894, "Annie" gave birth to four daughters: Gladys, Louise, Helen and Josephine. To recap, by J.J.'s retirement at age sixty in 1897, he had amassed millions of dollars in net worth (by 2010 standards), three companies, seven surviving children and two wives.

After abdicating his day-to-day duties with the businesses to his two surviving sons, John L. and Charles, J.J. set about the process of

building his dream home—almost. In order to build the mansion at the highest point of the hill and enjoy the best vista, J.J. moved an existing five-thousand-square-foot Italianate Eastlake home some one hundred yards west, requiring that the house be lifted onto logs and pulled by teams of oxen for nearly a year to reach its current location. Moreover, the land had suffered from erosion; a stone wall was built around the entire property, and tons of dirt were transported in order to achieve the terraced effect of the front lawn. After securing an adjacent lot for additional privacy and gardening purposes, construction on the mansion finally commenced in the fall of 1898.

Building the mansion itself created its own set of challenges that rendered the construction timeline of two years a sizeable feat. First, the building grounds mainly consisted of bedrock, and digging to create a foundation and lay a limestone block basement proved to be labor-intensive. The architects designed many of the mansion's fireplace mantels and other built-ins (detailed in extra individual blueprints) over a year before completion of the house, since some of the materials used—such as South African marble and Cuban mahogany—would have taken months to arrive. Moreover, because J.J. insisted on fourteen- and twelve-foot ceilings for the respective first and second floors, the dimensions worked against the possibility of using any mass-manufactured cornices, windows, etc., without throwing the scale of the building off kilter. Wood carving details had been achieved by hand, as were effects in creating the gold leaf/stenciled ceilings and the pressing and tinting of specially textured wallpapers to resemble hand-tooled leather or flocked velvet. Added to those factors was the fact that the sheer scale of the house exceeded by several thousand square feet any other home in Hannibal at the time. The challenges of maintaining consistently fine craftsmanship over such a large area were reflected in the dozens of blueprints, pre-drafts and sketches that exist to this day.

Construction of the Cruikshank mansion was completed by late 1900, but it was not until mid-1901 that the family conducted an open function in their new home. Over seven hundred guests attended the celebration, and the *St. Louis Post-Dispatch Sunday Magazine* devoted its front page to showcasing the estate, proclaiming the mansion "one of the finest country homes in Missouri"—a designation that would remain for several decades. A year later, Samuel Clemens would spend an evening there as part of his last visit to Hannibal, attracting an audience of over three hundred guests (not all of them invited) as he entertained from the

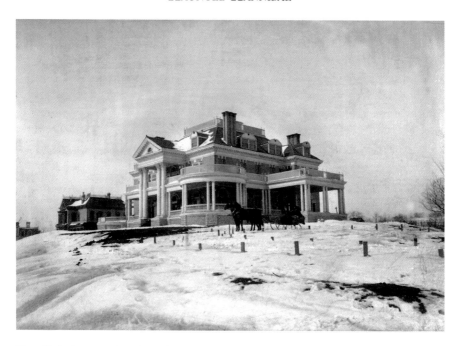

Hannibal photographer Anna Schnitzlin captured one of the earliest views of the Cruickshank mansion after its construction was completed in 1900. *Photo courtesy of Steve Chou.*

grand staircase for over an hour. During the near quarter-century that the Cruikshank family lived in the mansion, its doors opened for a multitude of functions: recitals, fundraisers, dinners, dances, etc. From what bits of evidence remain, such as invitations, news clippings and programs, Rockcliffe was built for the entertaining needs of a sociable family.

The St. Louis–based architecture firm of Barnett, Haynes and Barnett designed the mansion, and its floor plans provided a remarkably high level of flexibility for accommodating large groups. Looking at the first-floor plan, the arrangement of rooms resembled the modern-day equivalent of a Clue game board—one room flowing into another, pocket doors for every room save for the servant areas, exaggerated openings for the parlors (opening the double pocket doors felt as if a wall were being removed), a forty- by twenty-foot grand hall and staircase with an oversized landing and almost no traditional hallways. The second floor was designed in a manner that allowed movement between all three bathrooms and five of the six bedrooms without necessarily passing through the central foyer, allowing the foyer to work as an area for public functions (such as a place

to position musicians), while permitting the family to retain their own privacy. Amid the schoolroom and servants' quarters located on the third floor, a ballroom was completed that consumed over one thousand square feet of space, replete with a nearly eleven-foot ceiling and its own "fainting" or conversation room.

J.J. Cruikshank Jr. had ensured that the entirety of Rockcliffe would stand as a testament to the family's legacy and that the mansion would possess strength in structure that protected his loved ones for generations to come. Ironically, only one generation of Cruikshanks would live in the house. Just months after J.J. died of natural causes in his bedroom in March 1924, Annie moved out of the mansion and into the Italianate house next door, then occupied by her second-youngest daughter and son-in-law, Helen and Milt Knighton. Since Annie's other daughters had already married and moved off the property, the mansion remained unoccupied for well over forty-two years.

During the next several decades, the mansion served as a prime source of mystery and curiosity in the town, especially among the children. A servant was employed to tend the gardens and care for the most basic of functions concerning the mansion (such as preventing fire hazards and checking that the house was secure) for the first few years of its vacancy, but according to interviews with local residents who visited the property in the 1930s and beyond, the mansion grounds had already begun to slowly decline in condition by the end of the Great Depression.

By the '40s and beyond, Rockcliffe had evolved into what residents alternately titled the "Haunted House of Hannibal" or the "Haunted House on the Hill." Children who attended Central School at the foot of Rockcliffe's bluff would challenge each other to sneak into the house and bring back proof of their visits. A common thread among those interviewed involved the third-floor schoolroom. Apparently, the third and basement floors were more often infiltrated than the main and second floors. As a result, children would climb two levels of decaying wraparound verandas to reach the windows of the schoolroom. Once inside, pieces were torn from the hanging atlas map display that hung in the schoolroom as evidence of their bravery; as of this writing, at least two gentlemen claim to still have pieces from these maps.

The reason for largely avoiding the first and second floors was based on several factors. First, the Palladian windows on the first floor were difficult to break due to the plate glass involved. Second, because J.J. had died in the home, children believed that his spirit would still be present

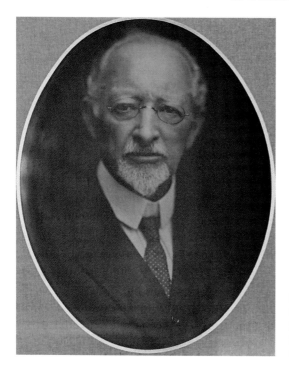

Undated portrait of John J. Cruickshank Jr. As an optical illusion, J.J.'s eyes appear to follow a person throughout the reception hall area.

in the family living quarters. Third, anyone who broke into the first two floors would have noticed that much of the family's belongings were left behind—clothes still in closets, furniture left in place—and that pictures of J.J. and Annie remained on the north wall of the reception hall. The portrait of J.J. had been posed by the photographer in a manner that caused his eyes to appear as if they were following people throughout that portion of the house.

In the sense of Rockcliffe serving as a rite of passage for local youth, nearly all of the local residents who were asked about their adventures did not want to be specifically identified or directly quoted, even displaying slight embarrassment; after all, the list of activities included make-out sessions, fireworks and BB target practice. Some 80 of the 125 windows that grace the building had received some type of damage. Windows to the third floor and basement were completely broken, while the first-floor windows were punctured with bullet and pellet holes (visible today). In some cases, the seats of several chairs were destroyed, presumably by children using them as trampolines. However, a sense of respect remained for the interior, as little of the woodwork throughout was defaced, and many other intricate details were left intact.

Time and the environment contributed to the balance of the damage. For years after the house was vacated, coal was burned to heat homes in the valley of the town; the resulting soot in the air passed through the many broken and punctured windows, coating the interior with a layer of grit. A fire ravaged the southeast portion of the wraparound verandas outside J.J.'s chamber and men's parlor in 1958, and by 1967 the mansion was considered an eyesore to the community and an endangerment to children. By then, Helen Cruikshank Knighton—who had been the only member of the family to remain on the estate in the neighboring house since her mother's passing in 1937—was presented with two choices by the City of Hannibal: either take measures necessary to bring the building up to code, an expensive proposition, or the mansion would have to be demolished.

One week before the mansion was slated to be razed, three local families joined to purchase the mansion from the Cruikshank estate, dividing the property just outside the veranda on the west side of the house. The Hartley, Roller and Raible families then recruited an array of volunteers from around town (too many to list), who set about the task of restoring the mansion. The restoration of Rockcliffe Mansion (originally, the entire estate was named "Rock Cliff" and "Rockcliff" for obvious reasons) required well over a year of labor and ingenuity, especially since the group did not have access to many proven preservation techniques at a time when restoration was not exactly commonplace.

The mansion opened to the public in 1968 and has served as a house museum ever since (as of this writing). Until 2005, the guided tours tended to downplay specifics on whether and how Rockcliffe was "haunted," regardless of incidents or evidence that would beg the question. When the mansion was sold in 2005 to former local media personality Rick Rose, the new owner claimed that it was, indeed, haunted. In the ensuing years, Rockcliffe appeared in numerous publications concerning haunted houses and hotels.

A large portion of Rockcliffe's mystique is due to the circumstances surrounding its forty-three years of vacancy. Because so little evidence remains to explain the personal lives of J.J. and Annie Cruikshank, speculation runs rife. The wife of a lumber baron leaves a mansion to live in a house less than half its size next door and then proceeds to watch the former home slowly head toward disrepair, day by day. Why wouldn't one of the daughters choose to move her family to Rockcliffe? Couldn't the mansion have been sold before it fell into disrepair? These questions

have been raised by visitor after visitor, incredulous that a home of such a grand scale would come so close to its demise.

Unfortunately, some of the speculation has led to assumptions about the relationship between J.J. and the rest of his immediate family. The theories usually cast Annie as an unhappy wife who did not want any part of the house after J.J. died or suggest that some dark event(s) must have occurred that prevented the daughters from living in a house that bore so much of their father's personality. These theories would help explain the reasons for the abandonment and subsequent haunting of Rockcliffe, but they cannot be supported with any hard evidence.

An alternate theory behind the abandonment and haunting of the mansion can be construed by stepping away from relationship dynamics and instead focusing on the circumstances surrounding the family at the time of J.J.'s passing. Because he had given the businesses to his sons from his first marriage years ago, his will did not include these items as part of his estate that would pass to the family of his second marriage. As part of that estate, any stock he retained concerning his old businesses would have lost value, considering that the lumber business in Hannibal was already heading into a slow, irreversible decline. With the estate having been bequeathed in equal amounts to Annie and her daughters, Annie would have faced the prospect of maintaining 100 percent of the property and mansion on 20 percent of the original resources, with little—if any—residual income. The daughters would have faced the same predicament; any decision to sell the property would have required agreement between all five women, since ownership of the mansion had also been evenly split between them. Without a consensus on how best to handle Rockcliffe, the mansion would serve as part time capsule, part storage unit. This is not taking into account any financial fallout resulting from the Great Depression.

Several factors suggest the possibility that the energies or spirits at Rockcliffe are protective in nature. When J.J. passed away, he was buried at the highest point of Riverside Cemetery (right next to Lover's Leap and directly across town from Rockcliffe), where from his monument one can look directly upon Rockcliffe, as if his intent was to watch over the mansion and his family eternally. Moreover, although the mansion was built with the finest and strongest materials possible, it survived decades of neglect and exposure to the elements (and potential vandals or thieves) that should have decimated it. Since 1967, whenever the museum has been in danger of closing or reverting into a private residence via "gut

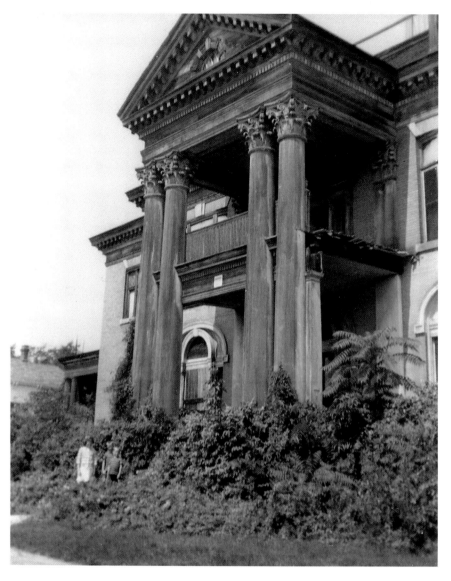

Photographed shortly before the scheduled demolition date in 1967, most of the mansion's double wraparound veranda had been destroyed by fire and the elements. *Photographer unknown.*

rehab," events somehow align that allow the mansion to remain open as an example of living history.

Where first-person accounts are concerned, we first encountered Rockcliffe unaware of any specific run-ins with spirits that others had

experienced. At the time, we felt an energy that combined graciousness with determination. The closest way to describe the essence in words would be the following: "We're glad you're here—it's time to get to work." Within the next two weeks, we learned that the museum and its contents could fall victim to foreclosure and/or the separate auctioning of its contents.

Within a week of staying at the mansion on a full-time basis, we would be awakened in the middle of the night by a single door slam, forceful enough to cause the echo of a window rattle. Since all of the screen doors had been locked and all of the windows were closed (nearly all have been painted shut), the sound could not be blamed on a cross-breeze or strong wind. The only potential culprit—a door that opened to the cupola from the third floor—had been pinned closed by a heavy ceramic urn. We tried recreating the sound by opening and slamming the door with different levels of force without success. This event would be repeated twice in the following eight months of our stay.

Other signals of a special presence would not resound so loudly but made just as obvious a statement. On our first day of managing the museum, one of us had turned on a chandelier hanging just above the top of the grand staircase. A tour guide and part-time housekeeper looked at us and asked how we were able to make the lights work; apparently, neither she nor anyone else in the mansion had been able to turn on the chandelier for months. Though everyone could turn it off via a push button–style switch, only one of us could press the "on" button and relight it successfully. Weeks later, separate checks by a licensed inspector and an electrician yielded the same verdict—the light switch was fully functional, and no electrical short could be detected in the circuit. However, on the day that a contract was accepted by the mansion's bankruptcy trustee from a party intent on closing the mansion, the chandelier turned off by itself and could not be relit by anyone for a solid month. The very morning that the same contract was voided, the chandelier lit again by itself. When our lease to maintain the museum expired, the light extinguished itself again and could not be activated throughout the rest of our time at the mansion.

A variety of more random events occurred during our time there, but the incidents were isolated and spaced several weeks to a month apart in frequency. One of the more enlightening moments was when we heard the sound of short but heavy steps coming from the direction of the servants' stairwell. We heard a number of steps diminishing in loudness and then

a pause, followed by a shorter series of steps. The pattern of steps heard matched exactly the number of steps from the first floor to the midway landing and from the landing to the second floor. Later, we would learn that a former caretaker had heard the same sounds and mentioned that J.J. would use the servants' staircase and exit occasionally if he wanted to escape the goings-on without being seen by family or visitors. As with any other events, the overall effect was very matter-of-fact in nature, as if to remind us that someone else was with us from time to time. From the abruptness and heaviness of the different sounds involved with these encounters, and because a firm majority of the design and furnishings reflect masculine tastes, we instinctively felt that the energies were linked to the protective tendencies of J.J.

From 2005 through mid-2010, the mansion has also served as a limited bed-and-breakfast, as its main function has always been as a museum. Overnight guests have occasionally reported that they could hear music coming from downstairs in the music or recital room, that they smelled cigar smoke in the gentlemen's parlor (J.J. routinely smoked cigars, but Rockcliffe has not allowed smoking inside since becoming a museum) or that a rocking chair would make noise without moving until the chair was removed to the hallway, among other curiosities. One couple, during a Halloween weekend, had quietly fled the mansion in the middle of the night because they felt that not only was the mansion haunted, but so was the entire town of Hannibal. The couple had called the following morning to explain and settle the bill. The wife of another couple the following month told us that she felt the sensation of someone sitting on the edge of the bed and holding her hand—except that her husband was facing away on the opposite side. Instead of being intimidated by the presence, she said that she felt comforted by the affectionate gesture.

One of the most definitive sources of information about spiritual activity at Rockcliffe Mansion is Mary McAvoy, who served with her husband, Jerry, as caretaker from 1993 until 2005 and returned as a tour guide in 2009. McAvoy remembers her first encounter happening in the third-floor ballroom. "I had been cleaning the room, and the mannequin with the [antique] maternity dress would always be facing the center of the room. I had my back to her, and when I turned around, she was facing the other mannequins." Her most common experience, she adds, was "hearing J.J. come inside from the servants' entrance at 2:00 a.m.

We would hear a loud door slam, the sound of heavy footsteps tromping upstairs. One time I decided to get up and stand at the door to the second floor. I not only heard the steps getting louder but felt as if he had brushed past me on the way to his bedroom.

Among other frequent occurrences was the sound of a piano coming from the music room (Annie was a classically trained pianist, but the last piano known to be in the music room had been donated to Hannibal High School in the 1920s) and brief apparitions in the servants' stairwell of a short, white-bearded man wearing a worn brown hat and coat. The description matches J.J.'s appearance in his later years, and the hat in question is part of the museum's collection (unfortunately, the coat also existed in the museum but was eventually removed). The coat and hat, McAvoy adds, allowed J.J. to leave the mansion and move about town incognito. Overall, she has felt three different types of spiritual entities: an older masculine presence, a slightly younger and lighter feminine spirit and the spirit of a playful girl. (Note: Annie remained next door and on the estate property until her death in 1937, and Helen Cruikshank Knighton was the only daughter to spend her entire life in Hannibal and on family property. When Helen passed in 1987, she had spent the last eighty-seven of her ninety-five years living in or beside the mansion. These facts may help in understanding the existence of different personalities.)

The last of the three entities presented itself during a visit from a local television crew. According to McAvoy:

KHQA [a station serving the Quincy-Hannibal region] had come over to tape a news program from inside the mansion. They taped the first half of the show on the first floor, and there were no problems. Not too long after they started taping the rest of the show on the second floor, people were running down the steps, asking me who else was in the house. I told them there was no one else, and one of them said that they could all hear a commotion upstairs, like the sounds of children playing around. When I mentioned that the ballroom was on the third floor, a cameraman went upstairs to see if he could catch anything on tape but was not successful.

Within the past year, two regional paranormal groups have been allowed to conduct investigations in the mansion. Both did not find any obvious sightings or clear dialogue, but mild, vague, electrically

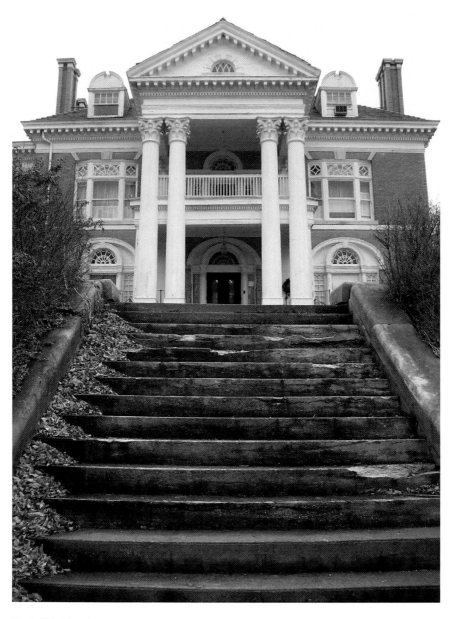

Rockcliffe Mansion has served as a house museum since 1968, after three Hannibal couples saved it from demolition and recruited dozens of volunteers in the restoration process. *Photo by Ken Marks.*

based disruptions were recorded. The verdict in both cases has been inconclusive, but leaders from the two independent teams have stated that a presence could be sensed yet not caught on camera or digital recorder. This would not be unusual of many houses that claim to be haunted; although testimonials about Rockcliffe's haunted nature would lead one to think that the mansion bustles with ghosts, the accumulation of these events span over eighty-five years, interspersed with long gaps of little or no activity noted.

The history of haunted incidents is voluminous enough that space and time do not allow us to discuss all of the details in this book. For example, enough unusual happenings occurred during a film shoot at the mansion in 2003 for McAvoy to keep track using a small notepad. The same could be said for our time at Rockcliffe—a culmination of benevolent and occasionally encouraging signals intent on keeping its history intact.

THE GIRL SUSPENDED IN MCDOWELL'S CAVE

No man "knew" the cave. That was an impossible thing...crooked aisles that ran into each other and out again and led nowhere. It was said that one might wander days and nights together through its intricate tangle of rifts and chasms and never find the end of the cave.
—*Mark Twain,* The Adventures of Tom Sawyer

The town of Hannibal is thought to sit atop a labyrinth of caves and caverns, with centuries of Mississippi River water stripping the limestone bluffs of their calcium to form miles and miles of stalagmites and stalactites. In 1819, an early settler of the area named Jack Simms was hunting along the foot of a steep bluff two miles south of what is now downtown Hannibal. Legend has it that Simms's dogs tracked a panther and chased it into a small hole in the side of one of the bluffs. Simms blocked the hole to keep the panther inside until he could return the next morning with a few other men. When they looked inside the hole, they were surprised to discover the entrance to an amazingly large cave. The cave became known as Simms' Cave, although some called it Saltpeter Cave after settlers in the area began to harvest its bat guano and use the saltpeter the guano contained to make gunpowder.

After its discovery, the cave became a popular picnic area and playground for Hannibalians. Sunday school classes would spend warm summer afternoons at the foot of the cave's bluff; families would gather

to fry catfish at the edge of the river; and many brave folks would carry torches into the chilly cave to explore the natural wonders it held.

It was also a great place for a hideout. The infamous robber Jesse James left his signature in the cave while hiding from the law, and slaves moving through the Underground Railroad used the cave to hide until it was safe for them to cross the Mississippi River into the free state of Illinois.

Sometime in the 1840s, the property that contained the cave was purchased by a wealthy St. Louis surgeon, Joseph Nash McDowell. Dr. McDowell's property stretched all the way to the river, and he built a boat landing there, as he typically traveled to Hannibal from St. Louis by boat. Friends of Dr. McDowell would sometimes stop over when coming up the river by steamboat and would visit the cave.

Dr. McDowell lost a daughter to pneumonia in 1849. He had often wondered if the cave's constant fifty-two-degree temperature, high humidity and pitch-black darkness would facilitate preservation of organic items stored in the cave. When his daughter died, he decided to experiment with her body to see if his theory was correct.

McDowell first constructed a copper cylinder lined with glass. He filled the large cylinder with an alcohol mixture (the recipe that Dr. Dowell used in this experiment is not known). He then placed his daughter's corpse inside the cylinder and, after placing a large metal rod into the ceiling of one of the rooms of the cave, hung the cylinder there with the intent to leave it for such a period of time as to preserve her body. To protect this secret experiment, Dr. McDowell secured the entrance to the cave with a heavy wooden door, strong iron chains and large padlocks.

However, Dr. McDowell underestimated the knowledge that Hannibalians had of the cave, especially young Mark Twain and his friends, who knew of several "air holes," as they called them—small entrances to the cave scattered around different places along the bluffs. Some of these boys eventually made their way into the cave and discovered Dr. McDowell's experiment.

After hearing the macabre tale of the corpse in the cave, numerous Hannibalians were compelled to sneak into the air holes on the bluff, drop down into the cave and seek out the cylinder hanging from the ceiling.

McDowell did not anticipate this possibility, as he had not constructed the cylinder to be very secure. Mark Twain, remembering the incident years later in his autobiographical *Life on the Mississippi*, wrote that "the top of the cylinder was removable, and it was said to be a common thing

In this early twentieth-century photo, the original entry to McDowell's Cave can be seen. Now called Mark Twain Cave, this entry is no longer accessible. *Photo courtesy of Steve Chou.*

for the baser order of tourists to drag the dead face into view and examine it and comment upon it." This story was also recounted in 1905 in *Mirror of Hannibal*, written by Thomas H. Bacon:

> *McDowell is credited with keeping in the cave a corpse of a child immersed in alcohol for some experimental reasons. Curiosity mongers were said to lift the corpse by the hair and expose the features of the remains.*

J. Hurley and Roberta (Roland) Hagood, in their book *Hannibal, Too*, explained the town's reaction to the discovery of McDowell's daughter in the cave: "When the grisly experiment came to the attention of the citizens of Hannibal, they were infuriated and caused the experimenting to end. The girl's body was removed from the cave. McDowell was disgraced, locally."

McDowell eventually took his daughter's body to its final resting place in the family mausoleum in St. Louis. Deciding then to remain in St.

Louis, Dr. McDowell was credited with forming the Missouri Medical College there and was considered a prominent citizen of St. Louis. It was rumored that McDowell, a Confederate sympathizer, stashed firearms at the college, an act that prompted Union forces occupying St. Louis during the Civil War to convert the medical college into a military prison.

During the Civil War, Bacon, the author of *Mirror of Hannibal*, met Dr. McDowell in Texas. Bacon said that McDowell was anxious to know if the cavern still bore his name. It would continue to be called McDowell's Cave for several years after the doctor's death in 1868, until the publishing of *The Adventures of Tom Sawyer* made the cave, and the book's author, internationally famous.

Today, the Mark Twain Cave is explored by tens of thousands of tourists each year. Guests are given a guided tour of the cave, now illuminated by electricity. On the tour, you will see Jesse James's signature on the wall of the cave and other intriguing aspects of the natural wonder, but you will not be able to see up close the room where McDowell's daughter was suspended in death. Sometimes the tour guides don't even relate the story of McDowell's experiment to guests visiting the cave.

Is the cave, in fact, haunted by the daughter of Dr. McDowell? It has been reported that some tour guides have felt a presence in the area of the cave where McDowell's experiment took place, and other guides are so spooked that they will not go into the cave alone.

In his book *Haunted Missouri*, Jason Offutt describes an interview he conducted with a former tour guide named Tom Rickey, who saw something in the cave during the late 1990s:

> *"I got a cold chill,"* [Rickey] *said. "I got them now thinking about it. I got a chill over me and I turned around and she was there."*
>
> *"She" was a girl wearing a long, old-fashioned dress with a cape.*
>
> *"I happened to look back in McDowell's room...and I saw her standing there as plain as day," Tom said. "She had long dark hair. Very, very pretty. She was only there for an instant."*
>
> *Thinking the girl was a lost tourist, he tried to speak to her, but she turned and walked into the cave room.*
>
> *"She walked off," Tom said. "She didn't fade away, but there wasn't nowhere to walk. She went through the wall. She just walked off and she wasn't there anymore."*

THE STILLWELL MURDER

HANNIBAL'S MOST SCANDALOUS CRIME

Fannie, is that you?
—*Amos J. Stillwell's final words*

Marriage—yes, it is the supreme felicity of life. I concede it. And it is also the supreme tragedy of life. The deeper the love the surer the tragedy. And the more disconsolating when it comes.
—*Letter from Mark Twain to Father Fitz-Simon, June 5, 1908*

On Saturday night, December 29, 1888, Captain William A. Munger and his wife, Anna, hosted a card party at their home located at 207 North Fifth Street in Hannibal. Among the guests in attendance were Amos J. Stillwell, his wife, Fannie, and several other notable Hannibalians, including the physician Dr. Joseph C. Hearne. The group gathered and played euchre, and Fannie Stillwell was awarded the first prize.

Making his fortune first in the pork-packing industry and later as president of the First National Bank of Hannibal, president of Hannibal Lumber Company and operator of one of the largest ice and cold storage businesses in the area, fifty-seven-year-old Amos Stillwell had become one of the wealthiest and most respected citizens in Hannibal.

Fannie, twenty years his junior, was Amos's second wife; his first wife, Mary, had died in 1868. Fannie, born and raised in Kentucky, was a beautiful girl with dark hair and a fair complexion. It was said she was well educated, an accomplished musician and, being a brilliant

conversationalist, could "fascinate" when she chose. Amos and Fannie had three children together and lived only two blocks from Captain Munger in a large, impressive home at the northwest corner of South Fifth and Church Streets.

It was rumored around town that for some time there had been trouble at the Stillwell Mansion; tension was sensed between Amos and Fannie. Just days before the card party, the gossip around Hannibal was that the couple had recently argued violently at the breakfast table, with Fannie finally throwing a coffee cup at her husband, narrowly missing him. However, at the Munger home that night, the couple seemed to be completely reconciled. Amos praised his wife's dress, attentions that, according to the other guests at the card party, appeared to please her greatly.

Shortly before midnight, the card party broke up, and Amos and Fannie Stillwell walked the two blocks south to their home. Their mansion housed a large room on the second floor that was used as the family's bedroom, featuring two beds, one for the children and one for the couple. On that night, the Stillwells' eldest daughter, Mary, whom the family called Mollie, was visiting relatives across the river in Quincy, Illinois. The other two children, Harold and Erle, who were being cared for by the Stillwells' servants Lizzie and Josie while Amos and Fannie attended the card party, were sleeping in one of the two beds.

Fannie was the first to retire to the bedroom, going upstairs to check on the children. Amos lingered downstairs to douse the gaslights and lock the front door. Fannie crawled into the children's bed to kiss them goodnight and decided to curl up and sleep with them; this left Amos to sleep alone in the other bed.

At about 1:30 a.m., Fannie was awakened by the sound of her husband's voice. As he rolled over in bed, he said, "Fannie, is that you?" Fannie then saw a figure crouched at the foot of her husband's bed, and as Amos spoke, the attacker lunged. Gleaming in the moonlight, Fannie could make out the shape of a two-edged axe in the intruder's hands. She then recalled hearing a whirring noise and the thud of the axe's blade as it struck her husband's head. She did not cry out; she simply hid under the covers and, for a time, lost consciousness.

When she finally came to, she climbed out of the children's bed, lit the gas lamp in the room and discovered her husband's body with a large gash across his face. Without a sound, she grabbed one of the boys and went in to the servants' room. There, she told Josie to light the gas and

Lizzie to bring the other child into their chamber, saying, "Mr. Stillwell's been murdered by a burglar, and I don't want the children to see him." The children were carried into the servants' room while they were still asleep, as they had also slept through the attack on their father.

Once the children were secure in the servants' quarters, Fannie ran down the stairs, barefoot and in her nightgown, and began to run up and down Fifth Street, pounding on neighbors' doors and calling for help. She was able to finally rouse her neighbor Dr. Allen, saying, "Oh doctor, Mr. Stillwell has been murdered by a burglar, and is lying in a pool of his own blood." Dr. Allen told Fannie that as soon as he and his wife were dressed they would come immediately to her aid.

Apparently, after talking with Dr. Allen, Fannie must have been in a state of shock. The Hannibal jail and police station was less than one block away from the Stillwell Mansion, but Fannie did not think to go down the street to the station and notify the police of the crime. Instead, she returned to her home to await Dr. Allen's arrival, went upstairs to the bedroom where her husband lay mortally wounded and began to clean up the blood.

Dr. Allen arrived, and shortly another neighbor, Dr. Gleason, joined him in examining the body. The wound from the axe had left a gash more than four inches long on the left side of the head. It had entered near the cheekbone, eliminated the left earlobe, severed the carotid artery and badly damaged the spinal cord. Amos had died instantaneously.

When examining the crime scene, it appeared to the two doctors that the body must have been moved slightly; the victim's feet were hanging off the bed, as if the body were about to kneel in prayer, and the blood that had saturated the mattress and dripped to the floor below had somehow not stained the victim's nightshirt. It seemed as if the body had been rolled over away from the blood into this unnatural position.

The doctors also took note that there were several chairs pushed up against the bed where the children had been sleeping, with pillows stacked high on the seat of each chair. When questioned about it later, first Fannie said she'd stacked the pillows to form a barrier between the children and their father so that they would not be able to see his body. (Later, her story changed; she was quoted as saying that before she went to sleep that night, she had pushed the chairs and pillows against the mattress to prevent the children from falling out of bed.)

After Drs. Allen and Gleason concluded their examination, the police were finally summoned. Meanwhile, Fannie called out for Dr. Hearne,

the family physician, and then promptly fainted. Dr. Hearne arrived at the Stillwell Mansion about the same time as the police, and after reviving Fannie, he asked the police not to interview her, as she was distraught and in shock. "That lady," Dr. Hearne was quoted as saying, "could not be examined. Her mental condition would not permit it." The doctor feared that at any moment Fannie might faint from the stress. The police concurred and did not attempt to question Fannie at that time. It would be five days before Dr. Hearne agreed to allow the coroner's jury to get a statement from Fannie, and only then if the jury would allow Dr. Hearne to remain in attendance.

Eventually, the newly elected, inexperienced coroner for Marion County, Wallace Armour, arrived at the crime scene. Armour, according to testimony from witnesses, entered the bedroom and made a hasty examination, soon allowing the body to be removed. Therefore, before dawn, before sunlight might aid investigators and just a few hours after the murder, all evidence of the crime had been removed and all traces of the violence cleaned away.

Initially, the police agreed with Fannie's assumption that the intruder was a burglar intent on stealing money from Amos Stillwell. However, if someone had planned to burgle the mansion, they were not successful in their attempt: the family's silverware, which was always kept in a bag on the mantle of the dining room, was left unmolested; Amos Stillwell's watch was found where it was normally kept; and some silver was still in the pocket of Amos's trousers. Money was found scattered in the backyard totaling approximately twenty-five dollars, but why the burglar would be so careless as to drop this money was not known.

Immediately after the crime, several African Americans in Hannibal were arrested on suspicion of murder and detained for several days, but they were eventually released for lack of evidence.

Amos Stillwell was laid to rest on January 1, 1889, and interred at Mt. Olivet Cemetery, just south of Hannibal. At the center of the family burial plot was placed a very large block of stone reading simply "Stillwell," and Amos was buried alongside his first wife, Mary. His headstone spoke nothing of the crime, listing only his name, birth date and death date.

Richard H. Stillwell, the son of Amos and Mary, offered a $10,000 reward for the arrest and conviction of the person or persons guilty of the murder or for information that would lead to such an arrest or conviction. He also hired two detectives of the Pinkerton Detective Agency to investigate the crime. After about three months, the Pinkerton

detectives told Richard that they had no reason to think they'd be able to solve the crime and abandoned their investigation.

No other arrests were made, and the case grew cold.

Exactly one year after the murder of Amos Stillwell, on December 28, 1889, Dr. Joseph Hearne and Fannie Stillwell were married. The ceremony took place at four o'clock in the afternoon in the front parlor of the residence of the bride, the Stillwell Mansion. This, of course, was the exact same room that only one year before had housed the body of Amos Stillwell during his funeral service.

News of the wedding caused a great sensation in Hannibal. As Dr. and Mrs. Hearne boarded the train at Hannibal's Union Depot to begin their honeymoon, a mob of angry Hannibalians gathered at the platform. Many insulting remarks were thrown at the departing couple, with some in the crowd shouting, "Fannie, is that you?"

Fearing persecution (and possible prosecution), Dr. Hearne and Fannie did not return to Hannibal after their honeymoon in Florida. They traveled around the country and eventually made their new residence in Los Angeles, California. However, the marriage was rocky from the start; on August 10, 1894, Fannie Hearne was granted a divorce from Dr. Hearne on the grounds of "Cruelty" and "Failure to Provide."

For reasons unknown, shortly after the divorce was final, Fannie remarried Dr. Hearne in Los Angeles. The ceremony was conducted by a justice of the peace.

In May 1895, while visiting the residence of W.T. Perkins in Palmyra (a small town just outside of Hannibal), Dr. Hearne and Fannie were arrested for the murder of Amos J. Stillwell. Their reason for visiting the Perkins home in Palmyra is unknown. "I suppose you have come to arrest me," said Dr. Hearne to the arresting officer, Sheriff Daugherty. "Yes, Sir," responded the sheriff. "Well, I am here and subject to your command," replied Dr. Hearne.

The trial began on December 11, 1895. It was decided that Dr. Hearne would be the first to stand trial. Because authorities did not believe they could find an impartial jury in Hannibal, the trial was moved thirty miles south to Bowling Green, Missouri. However, even in Bowling Green there was trouble with the jury; at one point, five members of the jury were dismissed after it was learned that they had visited the jail and talked with the defendants. Apparently, the sheriff enjoyed satisfying curiosity seekers by introducing them to the celebrity couple, including potential jury members.

After a lengthy trial and much testimony, Dr. Hearne was found not guilty and acquitted of the murder. The jury members later stated that they believed the state prosecutors had "failed materially in making out a case." While the state had strong circumstantial evidence, the judge had not allowed the prosecutors to admit as evidence the divorce and remarriage of Dr. and Fannie Hearne. In addition, other damaging testimony about the relationship between Dr. Hearne and Fannie prior to Amos's death was not allowed to be heard, testimony that alleged the couple had been intimate and that Dr. Hearne had been quoted as saying he planned to marry Fannie and would kill Amos Stillwell if he tried to stand in their way.

The Amos Stillwell Mansion, shown here circa early 1960s, was demolished to make way for a bank parking lot. *Photo courtesy of Steve Chou.*

As it was well known that the prosecution's evidence against Fannie was the same as that of Dr. Hearne, the grand jury had no reason to pursue a trial against Fannie, and she was released from jail in 1896.

Thus, the Stillwell murder is still, and may forever remain, unsolved.

The Stillwell Mansion on South Fifth Street was eventually demolished, and today the site is the home of the F&M Bank parking lot.

However, Captain Munger's house on North Fifth Street, two blocks north of the Stillwell Mansion and the site of the card party, is currently a restaurant named LaBinnah Bistro. (LaBinnah is simply "Hannibal" spelled backward and was the name adopted in the late 1890s by a men's social club, the LaBinnah Club). Chris Bobek, the owner and chef at LaBinnah, is convinced that the building is haunted.

Chris believes there is a presence that dwells mainly on the second floor and that it is a male presence. He and other staff members of the bistro have heard footsteps upstairs. From time to time, people dining at the bistro have asked the spirit there if it was present; upon doing so, the candle on their table was suddenly snuffed out.

Although we have no evidence pointing to the identity of the entity residing at the LaBinnah Bistro, could it be the ghost of Amos Stillwell still searching for his killer? Or, as his once grand mansion is no longer standing, could Amos have returned to the site where he spent his last happy moments alive?

The jury is still out.

Incidentally, four years prior to Amos Stillwell's death, in 1884, the extensive work entitled *History of Marion County, Missouri* by R.I. Holcombe was published. In the character sketch Holcombe produced of Amos J. Stillwell, he said, "[Stillwell] is one of Hannibal's most energetic citizens and one of Marion County's wealthiest men." Of Dr. Joseph C. Hearne, AM, MD, Holcombe wrote, "Dr. Hearne, though young in years, has a State [*sic*] reputation as a physician…His position in life is to be envied and his future is full of promise."

THE OLD CATHOLIC CHURCH

Blasphemy? No, it is not blasphemy. If God is as vast as that, he is above blasphemy; if He is as little as that, He is beneath it.
—Mark Twain, as quoted by Albert Bigelow Paine in Mark Twain, A Biography

In 1876, construction of the First Congregational Church was completed. The large, brick, Gothic-style structure, located at the corner of South Sixth and Lyon Streets, was just one block west from the residence of John J. and Mary Cruikshank, and its frame was built with lumber from the Cruikshank Lumber Company. It was noted in the *Mirror of Hannibal*, a town history written in 1905 by Thomas H. Bacon, that the structure was "one of the handsomest in Northeastern Missouri and by far the most costly construction of any in this immediate section."

While living in their home on Fifth Street, J.J. Cruikshank and his wife, Mary, obtained a divorce. The Cruikshank divorce was so sensational, and the alimony settlement so large, that it was reported in papers as far away as the *New York Times*. Of course, in the nineteenth century, divorce was rarely seen and widely controversial. The rift between friends and neighbors of the Cruikshank family, taking sides to support either the husband or the wife, finally divided the congregation of the church, and the First Congregational Church was dissolved.

In 1880, the structure was remodeled and furnished for use by those of the Catholic faith and rededicated as the Church of the Immaculate Conception. Father Dionysius Kennedy was the first to be in charge of

the parish, and the congregation grew to more than 350 families. The sanctuary would be their home until 1955, when the parish moved to the newly dedicated St. Mary's on Broadway.

After being deconsecrated by the Catholic Church, the building changed hands frequently over the next several decades, spending time as an American Legion hall, as a wedding reception and banquet facility and as the Molly Brown Dinner Theatre. One section of the building was converted and used for quite a long time as a bowling alley.

Beginning in 2001, the Hannibal Community Theatre began to perform plays and musicals in this location. It was then that the haunting of the church began to be discussed.

Jamie Grady, a member of the Hannibal Community Theatre as a performer and director, is convinced there are spirits that remain at the site. "I don't know who the spirits are that remain in the church building," Jamie explains, "but it feels as though every time you walk inside, you're walking into a room full of people, and they all stop talking as you walk in."

Jamie has had many firsthand experiences of paranormal activity while working and performing with the theatre group. It started with Jamie's very first production with the Hannibal Community Theatre:

> *During one of the intermissions of the show, several members of the audience, at separate times, approached our director to complain about the stage crew. They felt it was very unprofessional, and was detracting from the performance, for the stage crew to peek their heads around the stage-left curtain.*

However, as Jamie explains, this play only required one set, with no set changes or lighting changes. There was no stage crew for this performance! Further, Jamie felt it was significant that more than one person had witnessed these faces peeking around the curtain and that these people were seated in different areas of the audience.

Michael Gaines is the executive director of the Hannibal Arts Council. He spent three years living inside the old Catholic church while it was in use by the Hannibal Community Theatre.

> *The theatre was in the basement, my apartment was in the choir loft and the main sanctuary was unoccupied. The sanctuary is huge, about six thousand square feet, and there are three floors. In my apartment, I*

had twenty-five-foot-tall Gothic cathedral windows in the living room, the ceilings were thirty feet high and there was a balcony overlooking the sanctuary.

Michael is convinced that the sanctuary is haunted. "It was as if church services were still going on," he said.

I used to hear pipe organ music coming from the sanctuary when I was in the loft. Very faint, soft music, and definitely the type of music that would be played during a church service. But this building had no organ, no piano, no instruments of any kind.

Michael also heard sounds related to a congregation that might have gathered for a service, such as babies crying. "I could hear the sound of someone preaching," Michael said. "I couldn't make out exact words, it was a very faint sound, but I could tell by the inflection in the voice that someone was giving a sermon."

A member of the Hannibal Community Theatre group, who wishes to remain anonymous, was storing items in the loft apartment after a Christmas show. She reported to the group that she heard a male voice coming from the other side of the door that leads to the balcony. According to this lifelong Catholic, what she heard was, "*In nomine Patris, et Filii, et Spiritus Sancti.* Amen."—the Sign of the Cross in Latin. The layout of the church is such that the place where she was standing when she heard this would have been directly above the confessionals.

Another spirit witnessed by members of the theatre group may also be of the Catholic faith. "While doing a production of *Nunsense II: The Second Coming*, cast members were dressed as Dominican sisters in full black habits," Jamie explained. One of the actors assumed that a cast member was following her as she crossed behind the stage, but when she arrived at the wing she saw that the other cast members were already waiting at the wing for their next cue. She became frightened when she realized she had sensed an "extra" nun behind her. "All of the nuns in the cast were accounted for, three onstage, two in the left wing," said Jamie.

One night, after doing some research on the Internet, Michael opened one of the large, Gothic windows and sat on the edge of the sill. He began to read a prayer that he believed would encourage the spirits in the church to leave.

As I began to read, I felt a gust of air rush by me from inside the church, heading out the window. I mean, I physically felt this cold rush of air, it even rustled my hair! And it wasn't a breeze from the open window; it came from behind me inside and rushed out.

Michael said that after the night he read the prayer, he did not recall any other paranormal occurrences taking place inside the old Catholic church while he was present.

During the Hannibal Community Theatre's performance of *You're a Good Man, Charlie Brown*, one cast member shot a series of photos of the set that could be put together as a panorama of the entire stage. "There's a round anomaly [similar to a large orb] that changes location and moves through the sequence of photos," explains Jamie. Many other photos have been taken of performances at the church where orbs can also be seen. Jamie says she's not sure what she believes about the photos. "I don't believe these are dust particles, or light refractions or reflections on the film from the camera lens." She added, "I can tell the difference."

In the summer of 2006, Jamie was working at Rockcliffe Mansion as a tour guide. She took a group out to the old church to tell them some of the haunted experiences she'd had while working in the theatre.

There were about forty people on the tour. I was standing on the steps leading to the stage and they were all seated in the audience. I was telling them a story about a conversation I had one day with Heidi [another cast member of the theatre group]. [Heidi and I] were discussing all the paranormal things we'd seen, and I was telling Heidi my theory of the space/time continuum, meaning, in one dimension someone might hit a trashcan, and in another dimension the trashcan might barely move. As I was discussing this theory, Heidi and I turned to see a trashcan lid start flipping around.

As she was telling this story to the people on the haunted tour, one woman was videotaping the scene. Jamie told the group, "Just now, as I was telling you this story about my friend Heidi, I am getting chills just thinking about it." After the tour concluded, the lady videotaping came to Jamie to tell her why she'd felt the goose bumps at that moment. "She replayed her videotape for me, and as I'm saying, 'I am getting chills' you can hear footsteps walking up the wooden stairs I was sitting on. Some sort of being had walked right past me as I was talking to the group!"

In 2007, Jamie was directing *A Golden Fleecing* and had another strange experience:

> *I was sitting in the* [the tech booth that overlooks the auditorium]. *I noticed a man in a long overcoat that seemed to be pacing back and forth in the back of the theatre. My mother was in the audience and also saw this man. He was taller than average, wearing a long dark overcoat, and I couldn't see his face but he had a full head of graying hair. I was afraid his pacing might be distracting to the cast* [onstage], *so I signaled to my mother to ask the man to take his seat. Of course, when she went back to talk to him, he'd disappeared.*

Jamie related yet another tale of paranormal activity, this one showing that the spirits in the church seem to have a sense of humor. "Being a fan of irony, this next story is one of my favorites," said Jamie.

> *We always try to do something a little extra special for our audiences. During our production of* Bleacher Bums *we raffled* [St. Louis Cardinals baseball] *tickets. One particular show,* The Best Christmas Pageant Ever, *features a small story line about ham being more useful to a new family than frankincense and myrrh. So, we thought it would be funny to raffle off a ham from a local butcher shop for each performance.*
>
> *During the second act of one performance, Ileen Levy* [a longtime board member of the Hannibal Community Theatre] *was talking with another board member as they cleaned the concession stand. The ham to be raffled that night was displayed on the counter. As the two of them talked about finding a different venue for our group and selling the old church building, the ham flew off the counter and hit the wall on the other side of the hallway.*
>
> *We like to joke that while this event is paranormal, it was most likely Ileen's kinetic energy; she and her husband are Jewish. But, it was that event that convinced Ileen that there was definitely something to these claims of ghosts in the building.*

Jamie concluded the story by saying, "[Ileen] is now sure to tell them 'hello' and 'goodbye' upon entering and exiting the theatre."

Paranormal groups have done investigations of the old church, with startling results. One of the groups, a local Hannibal team, did a walk-through that Jamie was invited to attend. The group caught an EVP

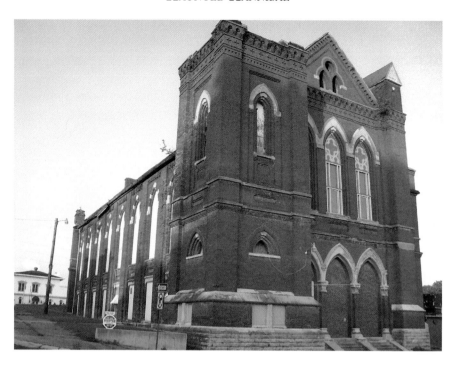

The old Catholic church, originally the First Congregational Church, is currently on Hannibal's most endangered building list. *Photo by Lisa Marks.*

(electronic voice phenomenon) recording in kitchen area. "You can clearly hear a man say, 'I'm busy now, ok?'" said Jamie. "Later on in the recording, a female voice says, 'It's ok, they ain't hurtin' nobody.'"

In 2010, the Hannibal Community Theatre was forced to relocate to the Star Theatre on South Main, and the old Catholic church is again vacant. Hannibal's city building inspectors believe the structure has deteriorated to the point of being unsafe. The church has been placed on the most endangered buildings list by city officials, meaning that if a buyer is not found and the building restored, in a short while it will be scheduled for demolition. At the time of this writing, the current asking price for the old Catholic church and property is listed as $35,000.

OLD BAPTIST CEMETERY
SPIRITS OF SLAVERY AND CIVIL WAR

It was a graveyard of the old-fashioned Western kind. It was on a hill, about a mile and a half from the village. It had a crazy board fence around it, which leaned inward in places, and outward the rest of the time, but stood upright nowhere. Grass and weeds grew rank over the whole cemetery. All the old graves were sunken in, there was not a tombstone on the place; round-topped, worm-eaten boards staggered over the graves, leaning for support and finding none. "Sacred to the memory of" So-and-So had been painted on them once, but it could no longer have been read, on the most of them, now, even if there had been light.
—*Mark Twain*, The Adventures of Tom Sawyer

One of our favorite places in Hannibal, and the last stop when we conduct our Haunted Hannibal tours, is Old Baptist Cemetery. Located two blocks north of Mark Twain Avenue, on the west end of Summer Street where it meets Section Street, the cemetery is well off the beaten path. As you step onto that hallowed ground you truly step back in time. There are no straight rows of shiny granite monuments that are seen in today's modern cemeteries; here, the stones are all caddy wampus, pitched in every direction by the upheaval of the soil by groundhogs and moles, the faces of the markers now sun-faded and water-damaged. Some tombstones, more than 150 years old, have fallen over and are mostly buried by years of soil erosion. Some have been completely covered over and may never be retrieved, with the headstone and the bones below now sharing the same dark grave. For history buffs and genealogists, and folks

who like the mystery and discovery of historical research, it doesn't get any better than this old cemetery.

Old Baptist Cemetery was founded in 1837 by the United Baptist Church of Hannibal. In April 1844, William T. Bridgeford filed a plot of the cemetery that showed one and one-quarter acres with two hundred cemetery lots. By 1857, the cemetery had been deeded to the United Baptist Church and had grown to just over three acres in size. Reverend Benjamin Q. Stevens, in charge of the church after his father died in 1869, was the last person known to have the deed to the cemetery in his name.

During the Civil War, the town of Hannibal was deeply divided between those who supported the Union and Southerners who had moved to town over the years as pioneers, who, because of their family ties and upbringing, were sympathetic to the Confederate cause. Northeast Missouri was nicknamed "Little Dixie" for a time because so many families had migrated to the region from Kentucky and Virginia. The Civil War brought much civil discourse to the small village of Hannibal.

Similarly, the congregation of the United Baptist Church also found itself no longer "united"; it was just as divided as many family, friends and neighbors were over the issues of the day. Soon after the outset of the Civil War, the congregation dissolved its church, and the United Baptist Church of Hannibal ceased to exist. The Old Baptist Cemetery was left with no one to look after its care.

Just a few years later, on March 10, 1871, the Mount Olivet Cemetery Association was incorporated. The association founded Mt. Olivet Cemetery, high on a hill at the south end of Hannibal. This became the "popular" cemetery in town, where many wealthy Hannibalians would erect huge monuments and mark off large family plots. Not only had Old Baptist Cemetery fallen out of fashion, but also it was downright unsightly and obviously neglected. Many of the families with loved ones interred at Old Baptist would choose to move their departed to Mt. Olivet. One promoter from the Mt. Olivet Cemetery Association was even successful in persuading Mark Twain to exhume the bodies of his father, John Marshal Clemens, and brother Henry (who died tragically aboard the steamboat *Pennsylvania*), having them removed from Old Baptist Cemetery and reinterred at Mt. Olivet in 1876.

Also in 1876, Mark Twain's masterpiece *The Adventures of Tom Sawyer* was published. In the story, Tom and Huck decide to try to cure warts by swinging a dead cat out at the cemetery; there, they witness Injun

Joe murdering Doc Robinson. Some believe that Old Baptist was Mark Twain's inspiration for the cemetery setting in *Tom Sawyer*. In 2000, Hannibalian Paul Fix earned the distinction of Eagle Scout by erecting an impressive sign of his own design out at Old Baptist that describes the Tom Sawyer legend.

After Old Baptist Cemetery was abandoned following the Civil War, the ownership of the cemetery became an issue, as no one would claim the property or expressed any interest in the responsibility of its upkeep. However, there were still burials at Old Baptist after the Civil War, with the cemetery being used particularly by black Hannibalians for their families. This practice continued until 1921, when the Robinson Cemetery, principally dedicated for members of Hannibal's black community, opened. It is still active today.

The last person to be buried at Old Baptist Cemetery, according to the dates on the headstones that can still be seen, was in 1957. In 1965, after no records could be located and no owner found, Old Baptist Cemetery was deeded to the City of Hannibal by the fifteen living heirs of Benjamin Q. Stevens.

In 2002, the Friends of Historic Hannibal and the Marion County Historical Society decided to restore the old cemetery and tackle the arduous task of plotting the graves and recording the names of the deceased who were buried there. A volunteer task force was established, and the team began to remove the dead trees, cut back the overgrowth and reset some of the headstones.

An article in the *Quincy* [Illinois] *Herald-Whig* by Edward Husar, published on April 7, 2002, explained:

> *Portions of the cemetery are overgrown in weeds and fallen trees. Many of the weather-worn tombstones have toppled over from the onslaught of time, erosion or vandalism. Most of the records associated with the cemetery have been lost, leaving many grave sites unmarked, their contents unknown.*
>
> *Several local groups, however, are launching an effort to bring the cemetery back into prominence…Those groups have "adopted" the cemetery as the focus of a long-term cleanup project…Weeds and trees will have to be cut back, and hundreds of tombstones will have to be cleaned, repaired and placed in an upright position. Many of the stones are now practically unreadable, but an effort will be made to retrieve some of the vanishing information before it is lost forever.*

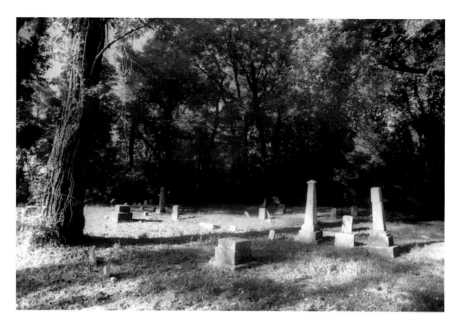

The Old Baptist Cemetery, one of the earliest cemeteries in Hannibal, was organized in 1837. *Photo by Ken Marks.*

Friends of Historic Hannibal, the Marion County Historical Society and the City of Hannibal continue to work together to maintain the cemetery grounds and preserve the history that is there. There is also an effort underway to have the Old Baptist Cemetery placed on the National Register of Historic Places.

When giving cemetery tours at Old Baptist, one of the first graves we visit is that of Agness Flautleroy, who died on July 16, 1855. Her headstone reads, "Agness Flautleroy, Slave of Sophia Hawkins." Sophia was the mother of Laura Hawkins, who is widely believed to have been Mark Twain's inspiration for the character of Becky Thatcher in *Adventures of Tom Sawyer*. It is extremely rare to find a marked slave grave site that still survives; how fortunate we are, as was Agness, that the Hawkins family so loved her that they buried her in a special place of prominence at Old Baptist and gave her a beautiful marble headstone. Agness, unlike most slaves, will not be forgotten.

Also buried at Old Baptist are a number of Union soldiers from the Civil War. Of particular interest are several from the Massachusetts Fifty-fifth, a regiment that was composed of entirely of African American soldiers. The 1989 movie *Glory*, for which Denzel Washington won an Academy Award, told the story of the first African American regiment to

Few slave markers are found with inscriptions like this one located at Old Baptist Cemetery. *Photo by Lisa Marks.*

fight for the Union, the Massachusetts Fifty-fourth. The Fifty-fifth was a sister regiment and faced a lot of the same challenges as the Fifty-fourth. Several volunteers from Hannibal were part of Fifty-fifth Massachusetts regiment and have this designation on their headstones at Old Baptist.

As we explore the old cemetery, guests we've taken on tour have snapped numerous photographs that reveal orbs dancing around the tombstones. Although some dismiss orbs in photographs as being dust particles or sunspots on the lens, today's digital cameras don't usually have these issues, and the high resolution of the cameras seem to reveal a level of detail that makes the possibility of detecting energy even more compelling. Besides, it is good clean fun, and it is another opportunity for guests to open their minds to the possibility that we are truly not alone.

A cold spot has also been consistently found at Old Baptist, near a large maple tree in the center of the cemetery. As we walk near the tree while giving a tour of the cemetery, nearly every group agrees that the area near the tree seems to be several degrees colder. When we sense this change in temperature, we are not walking from sunlight to shade, and there is no breeze present. There is also no significant change to the landscape. Curiously, the cold spot seems to move around, sometimes closer to the tree, sometimes farther away, but never more than thirty feet from the eastern face of the trunk. There's only been one tour so far that has not been able to sense the cold spot.

Once we had a gentleman on tour, a Vietnam vet who served in the U.S. Marine Corps. As he walked among the graves at Old Baptist, I noticed that he would make a special effort to pause and formally salute the soldiers buried there.

Later, we broke out sets of dowsing rods, simple L-shaped brass wires, and handed them out to the guests. Dowsing rods, which move when pulled by a nearby electromagnetic field, have been used for centuries to detect underground sources of water and other minerals. Ghost hunters today believe the rods are also useful to detect paranormal energy sources that may be present, as paranormal energies are thought to be electromagnetic. Our Vietnam vet, holding one rod in each hand, set out to experiment with his set of dowsing rods.

As he walked through the cemetery, his rods were perfectly parallel, sensing no significant energy. However, each time he approached one of the graves he'd saluted, the rods would quickly cross and form an X. As he backed away from the headstone, the rods would return to their neutral, parallel position.

The same type of incident happened on another tour with a lady from Texas. She found a tombstone at Old Baptist that identified John Long, the departed, who had also hailed from Texas. As she approached the stone, her dowsing rods would not only cross, but also they would begin

to spin around in a complete circle. Meanwhile, others in the group who approached the stone had very little movement with their rods. She seemed to personally connect to this gentleman from Texas, buried in Old Baptist in 1935.

There could be many explanations for this phenomenon. Is it the power of suggestion that these individuals are experiencing, subconsciously moving the rods in an emotional response to the connection they feel to the departed? Or do the energies that linger at the cemetery somehow have a psychic connection to what they perceive as a kindred spirit and then make an effort to connect with the living by moving the rods?

There is no conclusive answer to this, of course. But it is significant that as we walk among the dead at Old Baptist, we are able to share the story of the deceased and honor their memory with our guests. The guests, too, enjoy a special experience and leave the tour feeling as though they had the opportunity to reflect on the thin veil that separates the living and the dead. If they were able to connect with someone who lived in Hannibal one hundred years ago, then both the departed and the living share a moment and, in doing so, bridge the gap between the two worlds. There can be no harm in this.

The front entrance to Old Baptist Cemetery is modestly marked and nestled in the middle of a neighborhood. *Photo by Ken Marks.*

One guest told us something while on tour at Old Baptist that we will never forget. She said, "Remember the dash." She walked over to Anna Parson's grave, and the headstone read, "1860–1951." My guest said, "When you read this grave marker, you see the year she was born and the year she died. The 'dash' in between represents her entire life. Always remember the dash."

THE REAL INJUN JOE

Injun Joe sprang to his feet, his eyes flaming with passion, snatched up Potter's knife, and went creeping, catlike, and stooping round and round about the combatants, seeking an opportunity.
—*Mark Twain,* The Adventures of Tom Sawyer

Mark Twain's writings seemingly all contain thinly veiled accounts that were based on real-life events. His characters were usually drawn from real people as well. As Twain himself would write in the preface to *The Adventures of Tom Sawyer*:

> *Most of the adventures recorded in this book really occurred, one or two were experiences of my own, the rest of those boys who were schoolmates of mine. Huck Finn is drawn from life; Tom Sawyer also, but not from an individual; he is a combination of the characteristics of three boys whom I knew, and therefore belongs to the composite order of architecture.*

Twain does not mention his inspiration for Injun Joe, but most in Hannibal believe that the character stemmed from Twain's interaction with Hannibal's own real-life "Indian Joe."

The legend begins with a small, four-year-old Native American boy who had been reared in the grasses of the prairies in Indian Territory, later to be called Oklahoma. Some accounts state that the boy was of the Osage tribe. One day, sometime around 1825, the Pawnee, a warring

tribe from the same region, attacked the little boy's village. With the element of surprise on their side, the Pawnee overcame the encampment and massacred the entire tribe. The Pawnee were known to be scalpers and, once the killing was complete, set out to collect their war souvenirs, including the scalp of the four-year-old.

The young boy did not perish at the hands of the Pawnee, however, although he would be the only soul to survive the attack. The mutilated little boy had been left for dead, the lone witness to this horrendous tragedy.

Soon, bouncing along the prairie in his wagon, a white man named Douglas discovered the scene of the massacre. He found the four-year-old who had been left for dead and saved him, eventually adopting him as his own son. He named him Joe, Joe Douglas.

Young Joe could never grow his own hair and took to wearing a wig made of horsehair, a long, black wig fastened in the back as a ponytail. At some point in his life he'd contracted smallpox, as the scars on his face could attest. He was dark skinned; some thought him to have African blood mixed in with his Native American genes. Tragically, this fierce, savage look betrayed the gentle soul of Joe Douglas.

As an adult, Joe worked as a porter. As the large paddle wheels would pull up to the riverfront in Hannibal, Joe was at the ready to assist passengers with their baggage, sometimes helping travelers to their rooms at the Planter's Hotel on Main Street, sometimes unloading cargo and sometimes escorting local Hannibalians back to their homes after voyage on the boat. After the railroads came, Joe had even more opportunities to assist weary travelers.

In her book *Mary of Mark Twain's Home Town*, Mary Sibley Easton wrote:

> *Our family always engaged "Injun Joe" (mentioned by Mark Twain in Tom Sawyer) to haul our baggage. He had one of many one horse drays…"Injun Joe" always looked mighty fine to me in those days. Whenever I came back to Hannibal either on trains or by boat he would be standing there near his dray and would take off his hat and hold it near his heart and give me a very profound court bow and say, "Please, Miss Mary, may I tote your trunk home for you?" I always chose him out of the long line of dray-men.*

Mary went on to describe Joe:

> *He was short and heavy-set. He had keen eyes, long straight, oily black hair, a firm mouth and white teeth, but his nose was of the colored race.*

The colored people said he was part Injun and part colored and was "white livered" [cowardly] *and always carried a rabbit's foot in his pocket; but even that did not keep him from having the small pox. When I first saw him the pox marks only added a wild charm to his face.*

At some point, others added an "s" to Joe's last name, and he was known by both spellings, Douglas and Douglass. Some speculate that the additional "S" was attractive because of the popularity at that time of Frederick Douglass. Frederick Douglass had a wife named Anna; coincidentally, Joe Douglas would also marry a woman named Anna.

As Joe Douglas continued to work as a porter, he began to buy property at the foot of the bluff where Rockcliffe Mansion stands today, near the intersection of Eighth and Hill Streets, in the valley between the bluff to the south and Paris Avenue to the north. His property, which came to be known as Douglassville, became the area of Hannibal where African Americans would form a community, particularly after their emancipation in the mid-1860s. A three-room school for African Americans was built in 1870 by the Hannibal Public School System on Rock Street between Ninth and Tenth Streets and was named Douglassville School.

Joe Douglas lost his wife, Anna, in 1902, when she was only 52 (she was 29 years younger than her husband). He would continue to reside in Douglassville another 21 years, living to be approximately 102 years old (his birth date was never confirmed). Joe Douglas died in 1923 and was buried at Mt. Olivet Cemetery, only about one hundred feet and just down the hill from where the Clemens family rests.

Mark Twain never spoke of his inspiration for Injun Joe, and Joe Douglas, of course, denied being the model for the character. If there was a connection, one would suppose it was the look of Joe Douglas that Mark Twain remembered, the unusual pox-marked, dark-skinned man with the long ponytail wig. The characterization of the Injun Joe in *Tom Sawyer* was, of course, a figment of Twain's imagination.

Joe Douglas was one of the most respected Hannibalians during his lifetime and one of the most celebrated after his death. As Hannibal began to court tourists and capitalize on the celebrity of its most famous son, visitors became curious to see the grave site of Injun Joe. According to Shelley Fisher Fishkin in her book *Lighting Out for the Territory: Reflections on Mark Twain and American Culture*, Hurley Hagood reported that sometime in the 1980s the caretaker at Mt. Olivet Cemetery, Eugene Yarbrough, commissioned a new headstone for Joe Douglas's grave to assist tourists in finding the site.

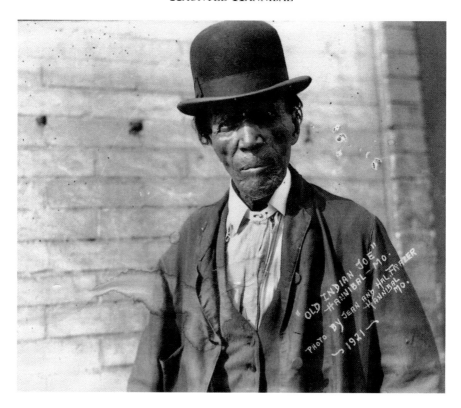

"Indian Joe," otherwise known as Joe Douglas, was photographed here in 1921 at the age of one hundred. He died in 1923. *Photo by Jean and Hal Frazer.*

The granite monument that still marks the grave today reads:

> *Injun Joe*
> *Joe Douglass, known to many in Hannibal as Injun Joe, died September 29, 1923 at age 102. He was found, an infant, in an abandoned Indian camp by a man named Douglass who raised him. He denied that he was the Injun Joe in Mark Twain's writings, as he had always lived an honorable life. He was buried from AME* [African Methodist Episcopal] *Church.*

As Ms. Fishkin would conclude:

> *While the inscription's reference to his "honorable life" might have pleased Joe Douglas, the cost—having Injun Joe emblazoned on his tombstone in oversized capital letters—might well have struck him as too high. ("Joe Douglas, Real Estate Developer" might have suited him just fine.)*

CHECKING OUT GARTH MEMORIAL LIBRARY

The man who does not read good books is no better than the man who can't.
—Mark Twain

T his gentleman, who died Oct. 12, 1899, was considered one of Marion County's most prominent and respected citizens," wrote Thomas H. Bacon in his 1905 publication, *Mirror of Hannibal*. "The great good accomplished by the subject of this sketch, and his surviving widow, will for several generations to come cause the name Garth to be highly honored and respected throughout this entire section."

John H. Garth was born in Virginia in 1837 and began his business career in Hannibal after graduating from the state university in Columbia, Missouri. He first made a fortune working with his father's tobacco business. Mark Twain, a childhood friend of John Garth, recalled in his autobiography:

> *In those days the native cigar was so cheap that a person who could afford anything could afford cigars. Mr. Garth had a great tobacco factory and he also had a small shop in the village for the retail sale of his products. He had one brand of cigars which even poverty itself was able to buy. He had these in stock a good many years and although they looked well enough on the outside, their insides had decayed to dust and would fly out like a puff of vapor when they were broken in two. This brand was very popular on account of its extreme cheapness. Mr. Garth had other brands which were cheap and some that were bad, but the supremacy over them enjoyed by this*

brand was indicated by its name. It was called "Garth's Damndest." We used to trade old newspapers for that brand.

In 1860, John Garth married Helen Kerchival, a native Hannibalian. Together they had two children. During the time of the Civil War, particularly because of the divisions and tensions of townspeople in Hannibal, Garth decided to relocate his family to New York City but returned to Hannibal in 1871. After his return, he served as president of the Farmer's and Merchant's Bank, owned a large lumber firm in Michigan and was also president of the Hannibal Lime Company. John and Helen Garth were always liberal with their wealth; John was particularly "revered by all for his many acts of philanthropy and charity," as reported in *Mirror of Hannibal*.

John H. Garth died in 1899. Just two years later, as a memorial to her beloved husband, Helen Garth and her daughter, Mrs. R.M. Goodlet of Kansas City, presented to Hannibal the donation of $25,000 for the design and construction of a new library. The library would be built just across the street from the Garths' mansion on Fifth Street, at the southeast corner of the intersection of Church Street (the Stillwell Mansion was located on the northwest corner of this intersection).

The John H. Garth Memorial Library was designed by the St. Louis architectural firm of Barnett, Haynes and Barnett (the same firm that had just completed construction of Rockcliffe Mansion for J.J. Cruikshank, who served on many boards and committees with John Garth). The building was erected by contractors from St. Louis, Lewis & Hall. As reported by Bacon in *Mirror of Hannibal*:

Exclusive of the site, the structure, which has an imposing appearance and is lavishly furnished, cost over $25,000. There are two stories and a basement to the library building. The superstructure is of stone while the main building is of buff colored brick with ornamental trimmings.

The Missouri General Assembly passed a bill in 1885 that any city in Missouri could fund a free public library (paid for with taxpayers' dollars). The Hannibal Library Association was formed, and Hannibal's public library became the first free public library in the state of Missouri. When the John H. Garth Memorial Library building was complete, the association's more than seven thousand volumes were moved to the new site. Hannibal held a parade and dedication ceremony for the library on February 15, 1902. Mark Twain, who had remained a friend of Helen Garth and would dine

with her on his final visit to Hannibal in the spring of 1902, certainly would have had the opportunity to congratulate her on the magnificent library.

Helen Garth lived more than twenty years after the library's dedication and was able to personally witness the enjoyment her generous gift to the city would provide to her fellow Hannibalians. Today, the Hannibal Free Public Library (as the Garth Memorial Library is now known) contains more than eighty-three thousand items and services more than sixteen thousand patrons.

One of these patrons is Elizabeth Tedrow, a former librarian at the Hannibal library, who currently has a valid, open library card in her name. Elizabeth just may be the most unique of the library's patrons, however; she's been dead for many years and is believed by some to now haunt the Hannibal library.

One librarian, who wishes to remain anonymous, said that the card is kept open for use when training new employees. It is also a nice tribute to the former librarian.

It was reported that for years the custodian of the library (now retired) was the person most convinced that the library was haunted. At one time, he requested that he be allowed to bring his dog into the library with him at night as he worked.

On July 9, 2010, while conducting one of our Haunted Hannibal ghost tours, we drove our guests toward the site of the Stillwell murder

The John H. Garth Memorial Library was completed in 1902, the first "free" or tax-supported library in Missouri. *Photo by Ken Marks.*

at the corner of Fifth and Church Streets. The Hannibal library is on the opposite corner. This was our evening tour, so it was well past seven o'clock and the library was closed. In our group were four ladies, a mother and three daughters, who were visiting from Chilicothe, Missouri.

Mary Kate Taylor, the middle daughter, looked up at the library as we passed and was surprised at what she saw. "There was a lady on the third floor," Mary said, convinced of what she'd seen.

> *She was sitting in the farthest window* [in the northeast corner of the building]. *Her hair was pulled back tight into a bun, and she was wearing a black dress with a collar and buttons down the front. The dress had a tight-fitted top. She was looking down at something, like she was reading a book.*

Mary Kate's mother, also named Mary, confirmed that her daughter has a special clairvoyant ability. "My husband can tell just by feeling that there is a presence in the room," explained Mary, "and my daughter will feel the same thing as my husband. I'm not sure why, but the rest of us don't have it quite as easily, not like my husband and daughter [Mary Kate]."

Across the street, the old Garth Mansion at 213 South Fifth Street has also had some unexplained occurrences. Stories have circulated around town for several years that the family who originally converted the mansion into a bed-and-breakfast in 1985 were witnesses to paranormal activity such as the sounds of footsteps and of furniture being dragged across the floor.

One specific incident occurred on a day when the lady who owned the Fifth Street B&B was alone. A visitor had come to the door of the mansion, and to avoid a long conversation, the owner made up a quick excuse that she had workers in the house that day and didn't have time to talk. Just then, footsteps and dragging sounds could be heard above on the second floor. The person at the door heard the activity, too, and, believing the story that there were workers present upstairs, said he would return at a more convenient time. The spirit in the mansion had tried to corroborate her tale and help rid her of her unwanted visitor!

A guest visiting the mansion snapped a very intriguing photograph in the front parlor. In the photograph of the parlor's closed pocket doors, faces could be seen peering out toward the camera, as though they were standing behind the person taking the picture with their faces being reflected in the highly polished wood. The faces appeared to be an older man and woman.

Is it possible that John and Helen Garth are still enjoying their beloved Fifth Street mansion today?

THE GIRLS AT LULABELLE'S

There is a charm about the forbidden that makes it unspeakably desirable.
—Mark Twain

Since the Roaring Twenties, 111 Bird Street has been one of the most famous, and infamous, addresses in all of Hannibal, for here one would find Lulabelle's. If you needed a sip during Prohibition, Lulabelle's was your destination. Soldiers traveling cross-country by train during World War II passed the word that, if you were lucky enough to stop in Hannibal, Missouri, you had to visit Lulabelle's. Local townsfolk knew they could relax and unwind for a few hours, and their privacy would be kept private, if they went to Lulabelle's.

In 1917, Sarah Smith made her way from Chicago to the banks of the Mississippi in Hannibal. At the foot of Bird Street, where it met the riverfront at Front Street, Madam Sarah began construction on a unique building, the only one known to be specifically designed and built for its particularly special purpose—namely, for use as the finest bordello in town. The square, brick building featured a speakeasy, restaurant, gambling hall and a "meet and greet" area on the first floor; upstairs, six rooms were available for private entertaining.

Lulabelle's was just one of many such businesses being conducted at that time in Hannibal, with that area of North Main Street being known as the town's red-light district. There was a men's store that sold hats and tobacco on the east side of the street and was rumored to house

a notoriously serious card game in the store's back room every night. Speakeasies dotted Main Street on both sides but were made more public when they converted to regular taverns after the repeal of Prohibition. And, of course, there were the brothels. One such establishment, on the east side of North Main, just a block away from the hat and tobacco shop, was a restaurant owned by a lady named Pauline. Her main source of income, however, was upstairs above the restaurant. Her girls would stand in front of the lace-draped windows on the second floor to advertise their services, and Pauline herself was frequently seen stepping outside to sweep the front stoop of her building wearing only her shoes.

As with most towns' red-light districts, many colorful characters would stop off at Hannibal as they traveled south to St. Louis or north to Iowa and Minnesota or west to Kansas City. Gamblers, railroad men, soldiers and traveling musicians all made their way to Lulabelle's at 111 Bird Street. Sarah Smith's business flourished throughout the 1920s and into the 1930s, until her untimely death in 1932.

After Sarah passed away, another madam, Bessie Heolscher, took up the torch at Lulabelle's and kept the red light burning. Bessie redecorated the interior of Lulabelle's with Spanish décor that had been made popular by talking motion pictures in the early 1930s, and the business continued to thrive, even in the midst of the Great Depression.

Hannibalians and the city's police seemed to be rather tolerant of the establishments in the red-light district. One theory is that, because all of these businesses were clustered in the same area at the north end of Main Street, people knew where the line was drawn, so to speak, and the police could keep that sort of activity contained in one specific area rather than having to worry about it being scattered here and there all over town. The rowdies and good-timers were all kept under a watchful eye and were tolerated as long as they didn't interfere with the respectable businesses and townspeople in other areas of the city.

Bessie and her girls were highly respected citizens in Hannibal. They were earning good money and would spend it with local merchants; they paid their bills on time. And they could keep secrets, many secrets—discretion was of vital importance, particularly to those clients who were local Hannibalians.

Hannibal's red-light district came to a rather abrupt end during the early 1950s. After World War II, America seemed to turn back to a more traditional sensibility, and areas of prostitution and gambling were forced to become more clandestine. In Hannibal, local ministers rallied their

congregations to denounce these vices and put pressure on the police to clean up Main Street. The end of an era was at hand.

Of course, the buildings that used to house the taverns and brothels in downtown Hannibal are now ice cream parlors, antique shops and stores that sell postcards and Mark Twain souvenirs. Only the stories remain, except at Lulabelle's.

The current owners of 111 Bird Street, Mike and Pam Ginsberg, have embraced their property's checkered past and celebrate the rich history of Lulabelle's. Today, they own a highly successful restaurant on the first floor of the old square brick building, and the dining room's décor includes framed Victorian undergarments. The stories of Sarah Smith and Bessie Heolscher are printed directly on the restaurant's menu. Upstairs, the six original rooms are now used as elegant bed-and-breakfast rooms, some with heart-shaped whirlpool tubs. There's even still a red light that hangs above the Lulabelle's sign over the front entrance.

Rumors have swirled around town for years that Lulabelle's is still haunted by Bessie's girls and the customers who requested their services. The smell of perfume, the sound of footsteps on the second floor, doors locking and unlocking and other strange phenomena were reported by

Lulabelle's was reputed to be the first building in downtown Hannibal to be built for the specific purpose of being a bordello. *Photo by Ken Marks.*

different visitors over the years. In the kitchen, staff members reported metal cooking utensils being moved and sometimes twisted out of shape, food and other small items flying across the kitchen and muffled voices being accompanied by shadows darting out of the room.

On October 31, 2008, the Paranormal Task Force and KZZK radio from Quincy, Illinois, teamed up to do an investigation and live broadcast from Lulabelle's. According to the task force's website, their investigation turned up a wide variety of unexplainable phenomena:

> *Some heard the voice of a lady who they could not see while others heard unexplainable footsteps. Moving areas of notable temperature decreases were also documented along with intelligent interaction by the unseen with an investigator's electromagnetic field (EMF) meter.*
>
> *One investigator was actually touched by the unseen when something softly stroked his arm with that special cold touch. A crew member of the KZZK team actually became so frightened that she ran outside the building screaming!*
>
> *Intelligent communication was also received through an experimental device called the Ovilus which was being field tested by our team at this location. The words "sex" and "pain" were said by this device multiple times while in close proximity to the room once used for prostitution. It even said the name of a KZZK crew member when he was near it on more than one occasion…*
>
> *Multiple Class B and C EVP's* [electronic voice phenomenon] *were captured throughout the night in various areas of this very historic and haunted location. Equipment documented smaller moving areas of notable temperature drops of up to five degrees coupled and higher erratic EMF readings were documented at times in responses to questions from individuals present as well.*

The task force's conclusions were that Lulabelle's produced many instances of "unexplainable activity" that was "paranormal in nature."

Currently, Mike and Pam continue to enjoy success at 111 Bird Street. In October 2009, the couple received special recognition from the National Restaurant Association with the Restaurant Neighbor Award, the most prestigious honor in the industry to recognize community service. Each Christmas, the Ginsbergs deliver more than 500 free meals to homes throughout Hannibal and serve another 150 free meals at Lulabelle's, a tradition that will celebrate its twentieth anniversary in 2010.

And so, as it has since the days of Sarah Smith, Lulabelle's continues to serve the community of Hannibal (although the methods of service have changed over the years). And as far as the ghosts of Lulabelle's are concerned, next time you are walking in downtown Hannibal, glance up at the square brick building at the end of Bird Street and see if you can make out the smiling face of a lady behind the lace curtains on the second floor, as so many visitors to Hannibal have done now for nearly a century.

JAVA JIVE AND
THE SPIRITS NEXT DOOR

I heard that kind of a sound that a ghost makes when it wants to tell about something that's on its mind and can't make itself understood.
—*Mark Twain,* The Adventures of Huckleberry Finn

North Main Street in Hannibal is today your quintessential historic town district. The old two- and three-story nineteenth-century buildings line both sides of the street, with glass storefronts advertising a variety of food, drink and shopping choices. Large planters are overflowing with annuals brave enough to endure the heat and humidity of summers near the Mississippi River. On certain days, one might see Tom and Becky, lucky Hannibal teens specially chosen as ambassadors for Hannibal who dress in costume and have a one-year commitment with the chamber of commerce to portray the famous characters from Mark Twain's *The Adventures of Tom Sawyer*, assisting visitors by answering questions and posing for photographs.

On the block of North Main between Bird Street and Center Street stand two rather innocuous-looking buildings: 211 North Main is the home of Java Jive ("The first coffee shop west of the Mississippi…we dare you to find one closer!") and next door, at 213 North Main, is a beauty parlor named the Powder Room. But many years ago, back when a tavern was called a speakeasy, these structures stood in what was known to be Hannibal's notorious red-light district.

Java Jive has been on North Main for about ten years. It is owned by Steve and Linn Ayers and managed by their daughter, Katy Welch. Steve and Linn have been actively restoring buildings in Hannibal for several years and also own Ayers Pottery, where Steve and his staff still produce thrown pottery by hand, as well as several other retail shops. They have owned quite a few of the downtown Hannibal buildings and were responsible for the restoration of the storefronts now seen.

Katy explained the history of these buildings, which her parents helped restore. "The building [now the Powder Room] was originally set up as a hotel in the 1800s. On the first floor was a bar called the Alibi. A man named Charlie Gun ran the bar with his girlfriend named Hanky." The hotel that Katy refers to was known to be a house of ill repute, with rooms most likely rented by the hour. "I think the old hotel and the bar were in a section of Main Street that was pretty rough for a while," said Katy.

"Charlie also owned the building at the corner of [North] Main and Bird," Katy continued. "In the back was illegal gambling. It had a side door that opened out onto Bird Street, and the gamblers would use that side door to enter for secret, high-stake games." Today, the corner store at 223 North Main is occupied by Hyland Antiques. Evidence can still be seen of Charlie and Hanky's occupancy, however; on the concrete doorstep of the corner building are their names, written while the cement was still wet.

The space now used for Java Jive was once known as Percy Haydon's Hardware store. Percy began in the hardware business in Hannibal back in 1908. According to J. Hurley and Roberta Hagood in their book *The Story of Hannibal*, Percy was "honored in 1958 at a banquet in St. Louis by the Association of Hardware Men for 50 years of continuous service in hardware." However, when the Alibi was in business, and the high-stakes gambling was going on down on the corner of the block, Percy had trouble with inventory disappearing from his store. Katy explained:

> *Some people would go into the corner building, slip a guy some money and say they wanted a toaster or something. There was a way to go through the tops of the buildings, all the way across the block, and someone could get into the hardware store through a hole in the attic. Percy Haydon couldn't figure out where all of his inventory was disappearing to!*

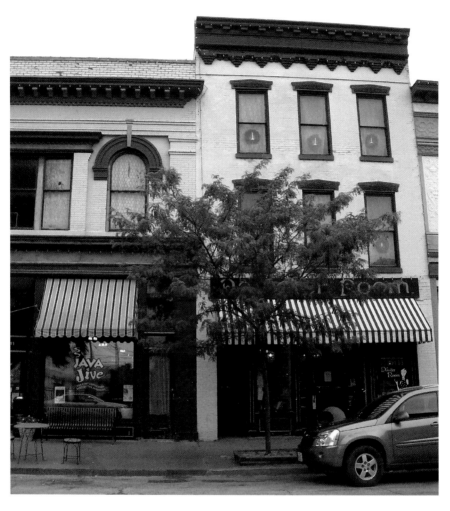

Paranormal events have been reported to originate from the third floor of a downtown building currently housing the Powder Room. *Photo by Ken Marks.*

Several witnesses have reported paranormal activities throughout the buildings on this block of North Main in the past few years. Katy believes she knows the spirits that now haunt the site. "We have our suspicions," Katy said. "When you add together gambling, alcohol, theft and prostitution, you have a pretty scary mix. I think past customers [of these establishments] and maybe some of the women who worked in the hotel are the ones still here."

Ashley Epperson, who worked at Java Jive with Katy in 2006, is still nervous about what she experienced. "I used to work the night shift alone," Ashley said, "and some nights I'd run out of the store without closing." She gave specific details of things she'd experienced. "There's a piano at Java Jive, and sometimes you could hear it playing, but the keys weren't moving. It was playing that old kind of music, like ragtime. It was really faint but you could hear it." Ashley also reported that she heard whispering sometimes and out of the corner of her eye would catch a shadow of someone walking by. "It felt like you were being watched," she added.

Katy had the same experience. "Sometimes I felt a presence," she explained.

> When we owned the building next door [where the Powder Room is now] there was a cinder block room in the back of the main floor that we used for the kitchen. The sink was in the back of the room, so you'd be working with your back to the door. So many times I'd feel like someone walked in behind me, like a co-worker, and I'd actually start talking or ask a question thinking I knew who had come in. Then I'd turn around and realize that no one was there. It happened regularly.

While Ashley and Katy have both had paranormal experiences at Java Jive, they both agree that the building next door that is now the Powder Room is more actively haunted. "It's real eerie over there," Katy said. Ashley agreed. "Things happened where the brothel was," she said. "There was a local [Hannibal] paranormal group who wanted to do an investigation of the upstairs, and we were allowed to do the brothel. We caught two EVPs."

Katy remembered the investigation. "When they were doing the voice recordings [EVPs] we got some eerie sound bites," she said.

> They first asked if anyone was present. Very clearly you can hear a screechy, nonhuman "Yes." The sound was definitely nonhuman, non-animal. The second question they asked was whether the person present was a man or a woman. Again, very clearly, you could hear "Man." There was another answer recorded but we couldn't understand, the voice was inaudible when we played it back.

"Some of my friends wanted to sleep up where the brothel was upstairs," said Ashley. "We thought it may be the same spirits that were

haunting Java." Katy remembered it, too. "Three or four begged to spend the night in the old hotel above 213," Katy said, "But it didn't last very long! They ran screaming out of the building and wouldn't retrieve their stuff the next day. They got pretty freaked out!"

"We scared ourselves," Ashley said, "but I still believe there's something up there."

Katy said that other groups have tried to investigate the brothel. "When they did tours up there, some people that were really sensitive to the spirits would come down shaking. They felt so much more emotional in the building than anywhere else they'd been." Dowsing rods were also sometimes used to detect electromagnetic energy. "The rods would spin around on their fingers!" Katy said.

Chris Bobek, the owner of the LaBinnah Bistro and Garden House B&B, was present for one of these investigations. "We took some people up to the second floor," Chris explained.

> But we asked them not to go on the third floor, it was unfinished. No electricity. It was daylight, so five or six people got adventuresome and went up to the third floor even though we'd asked them not to.
>
> In just a few minutes we could hear them running down the steps, all the way to the sidewalk outside, screaming as they came down. We came outside and asked what had happened, and they showed us the picture.

When the group went upstairs, one of them told the others to stand together for a group photo. "All around them were orbs, many orbs," said Chris.

> And above their heads, each one had a long, tall mist; it looked as tall as the person being photographed.
>
> Later we showed the photo to a friend of mine who is a paranormal investigator in Wisconsin. He said he thought that the orbs surrounding them were negative energy, and that the mists in the photo were actually guardian angels, one above each person, to protect them from the energies photographed as orbs.

Jenna Gould is the current manager at the Powder Room. "I used to work here on Mondays by myself and would get so creeped out," Jenna revealed. "Especially when I'm here by myself I feel like someone is watching me." Jenna says the office for the Powder Room is on the

second floor. "I hate going up there by myself," she said. Farther upstairs is used for storage. "We team up when we have to go up to get display stuff. I've been up there, it's not pretty!"

When asked if she's ever been to the third floor alone, or to the attic, she replied, "I have not, and I don't want to, especially after what Katy has told me."

Back at Java Jive, in addition to the piano music being heard, Ashley recalled many different instances of paranormal activity. "We had to go upstairs to take out the trash, the alley behind the building is one floor higher than Main Street," explained Ashley.

> But you could hear footsteps upstairs all the time. We would always feel creepy things when we were taking out the trash. Another girl [co-worker] went up to take out the trash, and when she came back down, all the lights had been shut off, the CD player was open and spinning and stuff had been knocked on the floor.

"It seemed to be mischievous," Ashley continued.

> It was an intelligent haunting, but positive. I think there is more than one entity, but I think one of them is Percy Haydon. He was a cigar-smoker, and sometimes when you'd hear the whispering, you'd hear a hacking cough too.

Katy said that it seems as though lately things have quieted down. "Since we sold the building [where the brothel once was] and there are two separate businesses, I haven't detected as much activity," she said. "I still feel sometimes like I'm being watched, but sometimes it's hard to decipher what is real and what is your imagination."

BLOOD ALLEY RUNS TO NORTH STREET

Too much of anything is bad, but too much of good whiskey *is barely enough.*
—*Mark Twain*

During the days of Prohibition and into the middle of the twentieth century, Hannibal's famed red-light district was in full bloom. Prostitution, gambling and bootlegging were widely practiced in the downtown area, and with crime seems to always come violence and danger.

An alley ran parallel to North Main behind the buildings on the west side of the street, in some places a full story higher in elevation from Main Street (as the ground slopes east toward the river). The alley continued all the way up to North Street. Because of the violence and crime the alley witnessed, it came to be known as "Blood Alley."

Debbie Harris is the owner of Ts & Trivia at the far end of North Street near Third. In 2010, she celebrated her twentieth year in business at that location.

"I bought the building from a lady everyone in the neighborhood called Granny Lee," Debbie explained. "It had been the home of her sisters, Alvina and Phoenita."

Granny Lee lived on North Street her entire life. The house just three doors up, now a souvenir shop called Twain Town owned by David Day, was her home for eighty-eight of her ninety-nine years. Granny Lee passed away in 2006.

"She was the daughter of one of the biggest bootleggers in Hannibal," Debbie said of Granny Lee. Granny Lee's father and mother lived in a small frame house on Cardiff Hill. "When they put the bridge across the river in the 1930s, they were going to tear their house down," said Debbie. "So they took the house apart board by board and moved it down here to North Street, and it's the small house that Granny Lee and her husband lived next door to." Eventually, Granny Lee and her husband followed in her father's footsteps and took up the family business of bootlegging.

The houses on North Street are built nearly directly against the face of the bluff that winds upward to the northeast and forms the base of Cardiff Hill. The bluff used to feature large, cavernous openings that led to tunnels that could be followed all the way to the banks of the Mississippi. "There was one cavern so large, right behind these buildings, that bootleggers could take a team of horses pulling a whiskey wagon into the cave," said Debbie. "Then they could drive the wagon through the tunnel to the river to meet the keelboats that would transport their whiskey up and down the Mississippi."

"Or, if the revenue man was coming," she added, "they could get to the river quick and dump their alcohol before they were caught."

In this eastward photo of North Street next to the Mississippi River, what remains of Blood Alley can be seen next to the first shop in the foreground. *Photo by Ken Marks.*

Unfortunately, when it was necessary to build a new bridge across the Mississippi in the 1930s, crews blasted the limestone bluff to create the roads that would lead to the bridge. In doing so, the cave walls collapsed and were filled in. Today, there are no cave entrances open from the southern face of the bluff under Cardiff Hill.

The name "Blood Alley" was attributed to the many razor fights, stabbings, shootings and other violence the alley played host to.

"One legend is that there was a black man who had been in a fight and his throat had been slit," Debbie revealed. "He was seen walking slowly down Blood Alley with one hand on his throat and one hand pushing down on the top of his head." He was asked by a witness why he wasn't running for help, why he didn't drop his hand. "He was afraid if he'd let go of his head, it might fall off," Debbie said. "The cut was that deep."

When Blood Alley was at its peak of activity, during Prohibition, Granny Lee and her husband owned a couple of tobacco shops on North Main Street. Similar to many businesses, the tobacco shops appeared respectable from the front, but behind the scenes were high-stakes poker games and other forms of illegal gambling. The couple also began dabbling in bootlegging. However, "all her adult life Granny Lee would only drink one shot of whiskey per day," said Debbie.

When Debbie bought the building on North Street from Granny Lee in 1990, she befriended the elderly lady. Debbie was fascinated by the family's history and by stories of Alvina and Phoenita. Soon, she realized that the two sisters had not quite left the building.

"I have had a lot of paranormal activity," Debbie said.

> *They had been coming around constantly when I first bought the building. Nothing bad, I think it's just the sisters letting themselves be known. I wouldn't use the microwave for a few days and suddenly it would start to beep. The doorbell out front, which most of the time wouldn't work, would begin to ring, and when I'd look out I couldn't see anyone on the front porch. Things would disappear and then reappear the next day, just small things.*

Debbie said the two sisters were known as the "White Ladies" because they had white hair, wore white outfits and painted the outside of the house and the adjoining cinder block wall with a fresh coat of white paint each year. "They even painted the sidewalk out front! But I couldn't paint [the concrete wall] every year, so when I decided to stipple paint the wall

I made a point of asking their forgiveness," Debbie said. "I could tell they weren't happy with me because a couple of things I noticed had disappeared weren't brought back for three or four days."

Debbie Overfield, who works for Debbie Harris at Ts & Trivia, also believed the sisters haunted the building. "I was back on the computer, in the room where the kitchen used to be," Debbie Overfield explained.

> *All of a sudden I could smell food cooking on a cast-iron skillet. First it was a smell like hamburgers, and later it smelled like salmon patties. It wasn't coming from the [Mark Twain] Dinette, it wasn't coming from Planter's Restaurant; it was right in the room. And it had that smell you can only get from using a cast-iron skillet like my mother used to use.*

She also felt as though she may have seen the quick movement of some sort of apparition on occasion. "Just shadow people out of the corner of your eye that aren't there," Overfield said.

Debbie Harris thinks the two sisters may have once intervened and prevented a disaster. She explained:

> *It was in August 1997, and it had been real hot and humid. When I'd close at night, I'd leave the window air conditioner on all night on low. I came in one morning and went over and the wall was black underneath the air conditioner. I put my hand on the wall where it was black and could feel it was hot. I ran and turned off the main breaker and called 911.*

Although there was no fire, the fire department came to check the safety of the wiring.

> *We had rewired the building when we bought it seven years before. The fire department cut a hole in the drywall to go back to follow [the source of the heat] and found that the plastic on the wiring was melted and charred eighteen inches back, and then had suddenly stopped. It didn't burn out on its own; the firemen said it looked like someone licked their fingers and stopped the flame in the same way you'd put out a candle.*

Debbie says she knows who snuffed out the fire. "That was some intervention from the other side," she said.

The last experience Debbie had at her building was three days after Granny Lee died in 2006. "I had some papers that Granny Lee had given me up on my bookshelf in my office," Debbie said.

> *All of a sudden, the papers all fell. I think her sisters were here waiting for her. The papers falling was their way of signaling to me that she was with them. It was only Granny Lee's stuff that fell. It was as if they were all just saying, "We're all together now, so bye!"*

Debbie has fond memories of Granny Lee. "When she was in her mid-nineties, the doctor told her she could no longer have her daily shot of whiskey because of her medication," said Debbie. "She was mad at the doctor for not letting her have her single shot."

Debbie also has a theory of how Granny Lee finally left Hannibal. "I believe that the night Granny Lee died she danced down the middle of Main Street," Debbie said with a smile. "Delightfully, as a young woman, having her body and her functions back. She loved Hannibal, loved Main Street, lived here her whole life. I think she found a bottle of whiskey, had her once-a-day shot and danced."

THE GHOSTS OF THE GARDEN HOUSE

I am opposed to millionaires, but it would be dangerous to offer me the position.
—Mark Twain

In the spring of 1893, Albert Wells Pettibone Jr. proudly received his degree from Yale University and was anxious to start the next chapter in his young life. Albert had decided to return immediately after his graduation to his hometown and join the family business, the Hannibal Saw Mill and Sash Company, the wildly successful business his father had begun and where his brother, Wilson Boyd Pettibone, was also an officer.

In January 1895, Albert married Miss Jessie C. Newell of Brooklyn, New York. The couple moved to Hannibal after the honeymoon. Anticipating the union, Albert had purchased property at the corner of Bird and Fifth Streets near Hannibal's Central Park. There, he began construction of a fine, Queen Anne–style Victorian home for himself and his new bride. The A.W. Pettibone Home was completed in 1896.

The happy couple welcomed a son, John Samuel, who was born in September 1895 while the home was still under construction. In February 1897, Albert and Jessie added a second son to the household, Wilson Newell. The future looked bright for the young, wealthy Pettibones as they looked ahead to the turn of the twentieth century.

Alas, their happiness would prove to be short-lived. While managing his father's sawmill in LaCrosse, Wisconsin, Albert Pettibone died of pneumonia on September 29, 1899, at the tender age of twenty-nine.

After Albert's death, his wife, Jessie, and the two boys would no longer be comfortable in the home Albert loved. Number 301 North Fifth Street was put up for sale and was quickly purchased by the C.H. Trowbridge family.

Charles Henry Trowbridge was another wealthy and influential Hannibalian as the president of the Duffy-Trowbridge Stove Manufacturing Company. The foundry was the largest heating and cooking stove manufacturing company in the Midwest, employing 225 men who churned out more than fifty thousand stoves per year. Charles and his wife, Nancy Duffy Trowbridge, moved into the Fifth Street house near the turn of the century (just as construction was being completed on Rockcliffe Mansion for John J. Cruikshank). They would also experience tragedy in the house at the corner of Fifth and Bird; according to Chris Bobek, the current owner of the house, the Trowbridges lost a son at the age of three while living on Fifth Street.

Today, Albert Pettibone's Queen Anne still reigns at 301 North Fifth Street and is now known as the Garden House Bed-and-Breakfast. Chris,

The A.W. Pettibone Jr. mansion, now the Garden House B&B, has been listed nationally as one of the best places to "sleep with a ghost." *Photo by Ken Marks.*

the owner of the Garden House, also owns LaBinnah Bistro (the two-story building at 207 North Fifth Street that, on December 29, 1888, was the scene of the card party hosted by Captain Munger where Amos Stillwell was last seen alive by his friends in Hannibal). Chris says with no hesitation that the bed-and-breakfast is haunted. He believes two spirits linger in the house; one of the spirits is a man and one is a small boy.

In 2006, the NBC *Today* show named the Garden House Bed-and-Breakfast one of the top ten places to "sleep with a ghost." The show sent out a camera crew and a paranormal investigator to do a segment on the haunted house. "The most significant activity was recorded in the attic above the East Room," Chris explains.

> *The camera crew was using those large shoulder cameras, and as they would pan across the attic, each time they came to a specific spot, the cameras would shut down. If they continued panning a little farther past, eventually the camera would come back up. They tried it several times, but each time the camera was pointed at a specific spot, it would shut down. The spirits here obviously did not want that section of the attic photographed.*

The cameramen also tried plugging their cameras into wall outlets to override their camera batteries, but with the same results.

Next, the crew went into the East Bedroom that overlooks the Mississippi River. "They took some footage inside the room," Chris said.

> *We began to leave the room, and the producer and I were the last ones out. At the same time we both turned and looked back into the room, and as we did, we both witnessed a depression in the bed, as if someone was sitting down looking out the window.*

Chris and the producer went back into the room to investigate.

> *There is a beautiful white comforter on this bed, with a nice feather mattress. I went over to the bed and smoothed out the bedding, pulling it tight, but after doing so, in a few minutes we could again see the impression of someone sitting at the end of the bed.*

At one point, one of the crew members became so overwhelmed by the energy in the house that she nearly fainted and had to be helped down the stairs.

As for the paranormal investigator in the group, his first impression was that one of the ghosts of the Garden House was angry. "Later in the day, he recanted his opinion," Chris said. "After considering all he was seeing on his equipment and the sensations he felt in the house, he finally concluded that the ghost was not angry, just very active, wanting us to know he was there." At this point, Chris became a bit emotional and, with tears in his eyes, told us, "Sometimes I can't believe that they are still here, that they choose to stay here with us."

Another example of paranormal activity in the house happened rather out of the blue. "We were in the Men's Parlor watching television," explained Chris.

> We heard noises that sounded like someone dragging a stick across cement. We didn't think anything unusual because the house behind us was being tuck-pointed, and when the workers would move their ladders sometimes they'd scrape against the brick and make a similar sound.

However, a few minutes later when Chris went into the kitchen, he was shocked to find the source of the strange noise.

> Our kitchen floor has ceramic tile, and when I went into the kitchen, the brass cover that is on the floor of the kitchen that covers the air vent had been pulled out of place, dragged across the kitchen floor and left squarely in the middle of the room.

Incidentally, the workers working on the tuck-pointing were not in attendance that day.

The little boy is also very active at the Garden House. "We set the table for breakfast the night before when we have bed-and-breakfast guests," said Chris.

> Many mornings we'll wake up and find that the silverware on the table has been moved around and is all askew. Once, the silverware was all pointing diagonally, as if a big magnet had been placed at the corner of the table and had pulled all the silverware the same direction.

Guests at the Garden House sometimes report strange experiences as well. In the hallway on the second floor, Chris placed a motion-activated light so that if guests get up in the middle of the night the light will

illuminate their path to the bathroom. Each room has a clear transom window above the door. Many guests have reported seeing the hallway light going off and on continually, as if someone is pacing in the hallway, but no footsteps are ever heard.

The dining room seems to hold special fascination with the ghosts at Garden House. Arif Dagin, a Turkish foreign exchange student who also lives at Garden House, was taking photographs of the house to send home to his family in Turkey. He took a photo of the dining room, but when he looked on the screen of his small digital camera he saw that the photo was a bit blurry. Arif nearly hit the delete button. "We reviewed all of the photos on the larger computer screen later," said Chris, "and when we did, in the photo of the dining room that was blurry, we could see the figures." The photograph is so compelling that Chris now sells it as a postcard to guests at the Garden House. In the photo is the image of what looks like a man seated at the dining room table, appearing to lean over to look down near the floor next to him. Near the floor, facing the camera, is the face of a small boy.

LOVER'S LEAP

LEGEND AND DIVINE INTERVENTION HIGH ABOVE HANNIBAL

Truth is stranger than fiction, but it is because Fiction is obliged to stick to possibilities;
Truth isn't.
—Mark Twain

The town of Hannibal is nestled in the valley between two high bluffs: to the north is Cardiff Hill, featuring the lighthouse, and to the south sits the 287-foot-high cliff that juts out toward the Mississippi known as Lover's Leap.

This natural wonder has always been a prominent landmark. The precipice of the cliff was a place of worship for Native Americans who roamed the area, and Europeans noted the unusual geographical formation in their maps and journals when the first explorations of the Mississippi River were conducted. Riverboat pilots could see Lover's Leap, even on moonless nights, and pinpoint their location. Many climbers have felt compelled to scamper up the north side of the bluff to witness the incredible view. Today, hundreds of thousands of guests visiting Hannibal drive to the top of Lover's Leap to look out over Hannibal, and from this high vantage point the town looks a bit like a miniature village created by a toy train enthusiast.

The name "Lover's Leap" was actually penned by Mark Twain's older brother, Orion Clemens. While on the newspaper staff in Hannibal, he wrote a rather sensational, and purely fictional, story about the famous cliff. According to Orion's story, a beautiful Indian maiden from the

Fox tribe and a courageous Indian brave from the Illinois tribe fell in love. Being from warring tribes, their parents would never allow them to marry. After a clandestine meeting, they were discovered together and chased up the steep bluff. Fearing that if they were captured the brave would be killed, they chose instead to leap from the cliff's peak, plunging to their deaths where they could remain together throughout eternity. The story was copied by other newsmen around the country, and as it was retold in other towns, similar legends were adopted. Thus a plethora of Lover's Leaps were christened.

On April 7, 1859, a large cave entrance was found on the face of the bluff of Lover's Leap. The opening had been revealed after a landslide along the south face of the cliff. Unfortunately, before it could be explored, another landslide sealed the newly found opening.

During the Civil War, Union troops occupied the summit of Lover's Leap and made their encampment there, placing a cannon nicknamed "Black Betty" at its peak. According to J. Hurley and Roberta Hagood in their book *Hannibal, Too*:

> *After the war got underway, soldiers from Quincy landed at the wharf in Hannibal on 8 June 1861. The regiment marched through the Main Street of Hannibal, placing the Unionists from Hannibal on the outside of the ranks, in positions where they would be easily seen by their secessionist neighbors.*

Also from *Hannibal, Too*, is the following report:

> *In 1888, A.W. Myers inflated a balloon over Lover's Leap. It rose from the summit, attained an altitude of fifteen hundred feet sailing westward. Myers jumped from the balloon and descended in a parachute landing at Klein's brewery. This parachute jump was seen by most of the residents of Hannibal.*

In 1909, two baseball players, both catchers from Waterloo, Iowa, captured attention by catching baseballs thrown from the top of Lover's Leap, a drop of more than 250 feet. The first catcher caught the first ball dropped to him; the second catcher missed his first toss but caught the second.

Vague rumors have circulated for decades throughout Hannibal that the area around Lover's Leap is haunted by a Native American warrior

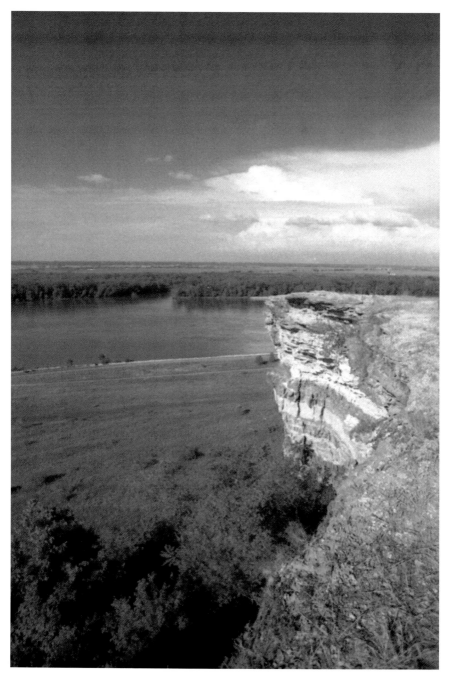

Located just south of Hannibal city limits on Highway 79, Lover's Leap towers almost directly above the Mississippi River. *Photo by Ken Marks.*

riding his ghostly steed throughout the woods. This folklore, told and retold in numerous locations across the country where tribes once lived, is almost too convenient a story to believe. However, true stories of people plunging from Lover's Leap, and all surviving, lend credibility to the notion that somehow Lover's Leap may be overseen by positive energies that help protect the unfortunate souls who find themselves tumbling over the edge of the cliff.

For example, in 1937, twelve-year-old Nettie Jane Ahlers was on a Girl Scout hike when she slid down a section of the steep cliff and, trying to make her way back, lost her footing again and rolled nearly to the bottom. She was able to recover from her injuries. A year later, in 1938, Robert Beckner, who was fourteen at the time, was hiking on the east side of the slope when he slipped, hit his head on a sharp rock and continued to roll down the steep incline. He, too, was able to recover from his serious injuries, including head trauma.

A much more compelling example of the possibility of positive forces protecting visitors at Lover's Leap is the story of two Illinois residents who, on August 12, 2009, plunged over the edge of the cliff in their automobile. As Brent Engel of the *Hannibal Courier-Post* reported later that day:

> *Ruth Hart and Nancy Strohl believe divine intervention saved them from a horrible death…Hart had been to Lover's Leap before and wanted to show her friend the dramatic view more than 200 feet above the city. So, she steered up the steep drive to the parking area at the top and thought she'd hit the right pedal. She hadn't. "I hit the gas instead of the brake," Hart said.*
>
> *The 2008 Toyota Camry leaped a parking abutment, ripped a hole in a wooden barrier and smashed through a chain link fence at the edge of the cliff. "When I saw us going through the fence, I was screaming so loud," Strohl recalled. "I thought we were goners. I thought we were going to end up in the river." The car plunged 30 feet down the sheer drop-off and flipped onto its top…a tree about three inches to four inches thick kept the vehicle from careening down the hill.*

The car flipped over and was snagged by a tree, suspended more than two hundred feet in the air. Ruth Hart's cellphone was lost when the car overturned; Nancy Strohl had left her phone at home. Fortunately for the two ladies, other tourists visiting Lover's Leap saw the car go over the

edge of the cliff and quickly called 911. They could hear Hart calling for help and honking the car's horn and soon were able to communicate to her that help was on the way.

The *Courier-Post* continued:

> *One of the department's new ladder trucks was used to lower* [firefighter Shane Jaeger] *by cable to the car. "They were a little nervous," Jaeger said. "We explained to them that we secured (the car) and it wasn't going anywhere."*
>
> *"We undid our seat belts because we were upside down,'" Hart said. "We were both on the roof of the car. It was pretty uncomfortable."*

The two ladies were rescued one at a time. Firefighter Jaeger was lowered by cable to the car, where he strapped one of the ladies to the cable so that the fire truck above on Lover's Leap could lift her to safety. Both were saved with no reported injuries. The *Courier-Post* reported that Ruth's Toyota suffered only light damage after a crane was brought up the cliff to hoist the car from the tree. As Nancy Strohl was reported to say later, "All's well that ends well."

However, after the accident, Ruth was haunted by the memories of the day she believed she had endangered the lives of herself and her friend Nancy. A follow-up story in the *Courier-Post* by Danny Henley in February 2010 reported that Ruth Hart had continuing nightmares about going over the cliff and that she was having trouble sleeping. "Physically I came out OK, but emotionally it's been kind of rough," Ruth was quoted as saying. "I'd go to bed at night, close my eyes and still see us going over the cliff. Since I was the one driving I felt responsible. It's really bothered me." Mentally, she continued to relive the moment of crashing through the fence and flying off the edge of the cliff, straight toward the Mississippi River from a height of more than two hundred feet.

In October 2009, Ruth received a recall notice from Toyota about the possibility that the gas pedal on some Toyota models may not function properly. After months of suffering with the notion that the accident on Lover's Leap was her fault, it was a relief to Ruth that it was possible she was not to blame. No one knows for sure what caused her car to suddenly surge over the edge, but Ruth now says she is sleeping better and has regained the confidence to drive again.

Could it be that divine intervention provided assistance and saved the lives of the two women on that fateful day in 2009, as well as in the

1930s when others survived near-death experiences at Lover's Leap? Is it conceivable that a three- or four-inch-diameter tree could cushion the fall of a car weighing several thousand pounds, suspending it in midair more than two hundred feet above the Mississippi River? Probably no one would ever want to recreate this scenario to prove or disprove the possibilities. But certainly, in Ruth Hart's mind, a positive force intervened that fateful day at Lover's Leap.

THE BENEVOLENT SPIRIT OF CLIFFSIDE MANSION

I think I have never been in a more beautiful home…than this palace of the king of humorists. The surroundings of the house are beautiful, and its quaint architecture… charm the attention and good taste of the passer by, for the home, inside and out, is the perfection of exquisite taste and harmony. But with all its architectural beauty and originality, the elegance of its interior finish and decorations, the greatest charm about the house is the atmosphere of "homelikeness" that pervades it. Charmingly as he can entertain thousands of people at a time from the platform, Mr. Clemens is even a more perfect entertainer in his home.
—*A letter by Mr. R.J. Burdette to the* Burlington [Iowa] Hawk-Eye, *as reported by the* New York Times, *January 2, 1881*

Two doors down from Rockcliffe sits another amazing Hannibal mansion named Cliffside. The mansion was designed by the famed architect Howard Van Doren Shaw and built for the W.B. Pettibone family in 1912.

Shaw, who was awarded the American Institute of Architects Gold Medal in 1926, was known for his organic designs that blended man-made structures with their natural surroundings, blurring the boundaries between indoors and out. Certainly, Cliffside exemplifies Shaw's style, featuring large sweeping French doors on the first floor that open to a croquet lawn flanked on either side by grand feminine statuary fountains. Down three steps from this formal patio area is a massive sweeping lawn that encompasses more than an acre of ground. To Shaw, this

large expanse of lawn was to be used for the *back* of the property; his philosophy was such that he believed families entertained in and enjoyed their backyards and therefore the backyard should be grand and more aesthetically important than the front. The "back" yard of Cliffside is actually what is seen as one travels west on Bird Street around to the curve of Stillwell Place.

Ah, yes, Stillwell. This name seems to haunt this book, doesn't it? In fact, before Cliffside's construction, the site was the location of the residence of Richard H. Stillwell, the eldest son of Amos J. Stillwell. In 1891, Richard Stillwell purchased the large Italianate home located at 1018 Bird Street that had been built in 1861 by Cyrus C. Godfrey. Richard, his wife Lulu (Voorhis) Stillwell and their children—Voorhis, Amos J. (named after his deceased grandfather), John D., Walter and Margaret—lived in what then became known as the Stillwell House. Just before the turn of the century, Richard subdivided the western half of the plot on which his home stood. This facilitated the creation of a new street, Stillwell Place, which extended Maple Avenue up to Hill Street. When the new street was created, the address for the Stillwell home changed from 1018 Bird Street to 8 Stillwell Place.

The Richard H. Stillwell family lived at 8 Stillwell Place until 1910, when Wilson Boyd Pettibone took over the property. W.B. (whose brother Albert built what is now the Garden House B&B) decided that the Stillwell home, which at the time was more than fifty years old, was in too poor of shape to sustain. After the Stillwell home was demolished in 1911, Shaw was retained to plan the new, grand Pettibone mansion that would now take up the lot at 8 Stillwell Place.

W.B. Pettibone, like Cruikshank and Garth, was one of the famed lumber barons of Hannibal, vastly wealthy and, fortunately for Hannibal, also greatly philanthropic. Although very private and modest about his good deeds, W.B. was very generous. He anonymously donated vast sums of money to assist in the construction and maintenance of a hospital, a home for orphans, numerous schools and their playgrounds and a youth camp with a swimming pool (quite an innovation in the early years of the twentieth century). When the dirt and mud streets of Hannibal were to be paved, W.B. Pettibone contributed to their funding. When buildings in Hannibal were dangerously neglected, W.B. would purchase them, pay for their demolition and then finance the landscaping to create small city parks.

According to J. Hurley and Roberta Hagood in *Hannibal, Too*:

> *One of* [Pettibone's] *most memorable charitable acts was during the Depression of the 1930s. More than 3,000 Hannibal school children had been participating in a school savings program designed to teach thrift and savings. During a certain hour on one specific day of the week, children brought their pennies, nickels and coins to school and deposited them in the school savings bank. Each child had a passbook in which his savings were recorded. Unfortunately, the Hannibal Trust Company in which the school system deposited the children's savings failed and was closed. Pettibone was not involved with the Hannibal Trust Company. He was president of the Hannibal National Bank, but he guaranteed personally the full amount of savings to each child whose funds were in the defunct bank. No child lost any of their savings.*

One other gracious contribution to Hannibal was made by the Pettibone family just prior to the construction of Cliffside. A beautiful parcel of land, over 450 acres of prime real estate overlooking the Mississippi River, was donated to the city of Hannibal to form what is now known as Riverview Park. Pettibone also bought parcels of land around the perimeter of the park area so that no encroachment of development would spoil the park's ambiance. He retained O.C. Simonds, a world-renown landscape architect (and the person selected by J.J. Cruikshank to design the gardens for Rockcliffe in 1901) to plan the park's design and oversee its construction. Simonds implemented a series of winding carriage paths to lead park visitors through specially planned garden areas and to scenic points with breathtaking views of the river. Riverview Park was completed in 1909 and today is one of the crown jewels of Hannibal. The park is a popular tourist destination that features a large statue of Mark Twain standing majestically at the precipice of a tall bluff, looking out over his beloved Mississippi River; this is the statue that Mary Sibley Easton admired on her final visit to Hannibal and wrote of in *Mary of Mark Twain's Home Town*. Riverview Park is also listed on the National Register of Historic Places.

W.B. Pettibone and his wife, Laura, moved into Cliffside Mansion sometime in 1912. The mansion boasted nine bedrooms, seven full bathrooms and quarters on the east side of the second floor large enough for four servants to live comfortably. A grand, curving stairway led guests from the impressive formal entrance up and over the front door to the

second floor. The large formal dining room was of French design, with gilt-framed walls, hidden cupboards for silver and china and a large fireplace with a stone mantle. The dining room's immense chandelier dripped with crystal prisms and hung over the dining table that could seat up to twenty guests. A large, glass-enclosed sunroom on the east side of the house was mirrored by an open portico with stone columns to the west. Brick courtyards, retaining walls, walkways and garden enclosures completed the formal outdoor spaces in Shaw's design.

Laura Pettibone passed away in 1923, and W.B. remained at Cliffside until his death at age eighty-eight in 1946. Wells Pettibone, nephew of W.B., resided at the mansion for three years following his uncle's passing. From 1949 until 1956, Cliffside was the home of Garvey and Emma Lyons, as Garvey was in charge of the Durasteel plant in Hannibal.

In January 1958, the new owners of Cliffside, William and Shirley Bridges, announced the opening of Shady Lawn Convalescent Home. They had converted the mansion for use as a nursing facility, with entrances being changed and some rooms altered. It remained in this capacity until 1987, at which time it was purchased and use as a facility for the Tabernacle of Praise. Then, in the 1990s, it was opened as a bed-and-breakfast by Franklin "Bud" Winters and his wife, Nina. Eventually, Cliffside again returned to being a private home and for a short time was occupied by the Ostrowski family. Today, it is owned by Jim and Sheryl Love of Chino Hills, California.

Rumors have swirled for years about Cliffside Mansion being haunted. With the structure being used as a convalescent home for thirty years, and some patients passing away after spending time there, it is not too far-fetched to imagine that some spirits remain.

Charles King of Hannibal, whose wife is a relative of Bud and Nina Winters, tells a story from November 2002:

> We were at Cliffside to have our family holiday photos taken. As we were getting ready, my oldest daughter Lissa, who was two at the time, toddled off on her own. When she returned, we asked where she'd been. "Playing with a lady," she said. But there was no one else in the house other than our family! So we asked her where the lady was now. She said, "The lady said she had to leave."

A similar story circulated that children living in and visiting Cliffside told stories of playing with "Mary." At first, the family thought Mary was

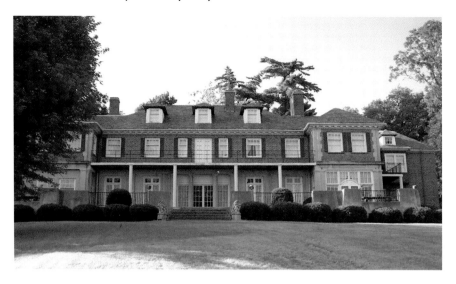

Cliffside Mansion, built in 1912 by renowned architect Howard Van Doren Shaw, housed a convalescent home for three decades starting in 1958. *Photo by Ken Marks.*

a neighborhood child; later, they learned that the children were going to a room on the west side of the second floor to play with a lady named Mary who they said visited the room.

Today, Cliffside Mansion is owned by Jim and Sheryl Love. Jim Love spent a large portion of his childhood in Hannibal, and in 2006, when the couple was looking for a vacation home where family members from across the country could meet, Cliffside, in centrally located Hannibal, was the perfect choice. Beginning in the summer of 2010, Jim and Sheryl have graciously agreed to open Cliffside to the public for tours and special events.

Visitors to the mansion sense that it is a real home. Its architecture is magnificent, world-class, but the mansion is not a museum. Every July, more than forty family members descend on the mansion; badminton nets go up in the sweeping backyard, flags are draped from the second-floor balconies and children can be heard running up and down the stairs. It is truly a home. And if there are lingering energies at Cliffside, they, too, make it feel like home. "If there is a ghost," Sheryl believes, "It is a benevolent, happy ghost. The house has such a welcoming feel when you enter."

The same could also be said of Hannibal, Missouri.

BIBLIOGRAPHY

Bacon, Thomas H. *Mirror of Hannibal 1905*. Revised and reprinted by J. Hurley and Roberta (Roland) Hagood. Hannibal, MO: Hannibal Free Public Library/Jostens (Marceline, MO), 1990.

Burdette, R.J. "'The Home of Mark Twain: The Pleasant Impressions It Made Upon the Iowa Humorist,' Letter to *Burlington* [Iowa] *Hawk-Eye* as reported by the *New York Times*, January 2, 1881." *New York Times*. Available online at http://query.nytimes.com/gst/abstract.html?res=9C00E3D71630EE3ABC4A53DFB766838A699FDE (accessed June 2010).

Dawson, Minnie T. "The Stillwell Murder or a Society Crime." Edited by Chase Hickman. Hannibal Free Public Library. www.hannibal.lib.mo.us/stillwell.htm.

Easton, Mary Sibley. *Mary of Mark Twain's Hometown*. Milwaukee, WI: Olsen Publishing Co., ca. 1930.

Engel, Brent. "Two Women Rescued after Car Plunges Off Lover's Leap." *Hannibal Courier-Post*. Available online at www.hannibal.net/multimedia/x1591367851/Two-women-rescued-after-car-plunges-off-Lovers-Leap (accessed May 2010).

Fishkin, Shelley Fisher. *Lighting Out for the Territory: Reflections on Mark Twain and American Culture*. New York: Oxford University Press, 1997.

Gilbert, Joan. *Missouri Ghosts III*. Hallsville, MO: Mogho Books, LLC, 2006.

Greene, Virginia A. *The Architecture of Howard Van Doren Shaw*. Chicago: Chicago Review Press, 1998.

Hagood, J. Hurley, and Roberta Hagood. *Hannibal, Too: Historic Sketches of Hannibal and Its Neighbors*, Marceline, MO: Walsworth Publishing Co., 1986.

————. *Hannibal's Yesterdays*. Marceline, MO: Jostens Publishing, 1992.

————. *The Story of Hannibal: A Bicentennial History, 1976*. Hannibal, MO: Hannibal Free Public Library/Standard Printing Co., 1976.

Hagood, J. Hurley, Roberta Hagood and Dave Thomson. *Hannibal Heritage*. Marceline, MO: Heritage House Publishing, 1994.

Henley, Danny. "Nightmares of Lover's Leap Plunge Still Haunt Driver." *Hannibal Courier-Post*. Available online at www.hannibal.net/accidents/x655689818/Nightmares-of-Lover-s-Leap-plunge-still-haunt-driver (accessed May 2010).

Holcombe, R.I. *History of Marion County Missouri 1884*. Reprinted for the Marion County Historical Society by J. Hurley and Roberta Hagood and Henry Sweets. Marceline, MO: Walsworth, 1979.

Husar, Edward. "Raising Historical Consciousness: Volunteers Are Being Sought to Restore Hannibal's Legendary Old Baptist Cemetery." *Quincy Herald-Whig*, April 7, 2002.

Offutt, Jason. "The Ghost of Mark Twain Cave." From *The Shadows: True Tales of the Paranormal*. Available online at http://from-the-shadows.blogspot.com/2006/11/ghost-of-mark-twain-cave.html (accessed June 2010).

Paine, Albert Bigelow. *Mark Twain, A Biography: The Personal and Literary Life of Samuel Longhorne Clemens*. New York: Harper & Bros., 1912.

Paranormal Task Force. "Paranormal Task Force Report of Lulabelle's 10/30/2008." Haunted Lulabelle's. http://www.paranormaltaskforce.com/lulabelles.html.

Powers, Ron. *Dangerous Water: A Biography of the Boy Who Became Mark Twain*. New York: Basic Books, 1999.

Thomson, Dave. "Tom Sawyer's Cemetery." Twain Quotes. http://www.twainquotes.com/TSCemetery.html.

Twain, Mark. *The Adventures of Huckleberry Finn: The Only Comprehensive Edition*. Foreword and Addendum by Victor Doyno. New York: Random House, 1996.

————. *The Adventures of Tom Sawyer*. New York: Oxford University Press, 1996.

————. *Following the Equator*. New York: Oxford University Press, 1996.

————. *The Innocents Abroad*. New York: Oxford University Press, 1996.

————. *Life on the Mississippi*. New York: Oxford University Press, 1996.

————.*Old Times on the Mississippi*. New York: Oxford University Press, 1996.

Twain, Mark, and Charles Dudley Warner. *The Gilded Age*. New York: Quill Pen Classics, 2008.

Wikipedia. "Society for Psychical Research." Wikipedia, The Free Encyclopedia. http://en.wikipedia.org/wiki/Society_for_Psychical_Research.

ABOUT THE AUTHORS

K en and Lisa Marks were born and raised in St. Louis but are now full-fledged Hannibalians. Through their company, Historic Hannibal Tours, LLC, they offer guided historic tours and Haunted Hannibal Ghost Tours™. They also own The Gilded Age, an antiques and collectibles boutique in Hannibal's Main Street Historic District. Lifelong history fanatics, they are members of the Friends of Historic Hannibal and the Marion County Historical Society and are lovingly restoring their 1885 Second Empire home located in the Central Park Historic District in Hannibal. They are committed to historic preservation and are working with other Hannibalians to preserve and protect the precious structures in Mark Twain's hometown.

Photo courtesy of Michael Kipley, Quincy *[Illinois]* Herald-Whig.

Visit us at
www.historypress.net